D0453089

Paint a watercolour landscape in minutes

ATMOSPHERE, MOOD and LIGHT

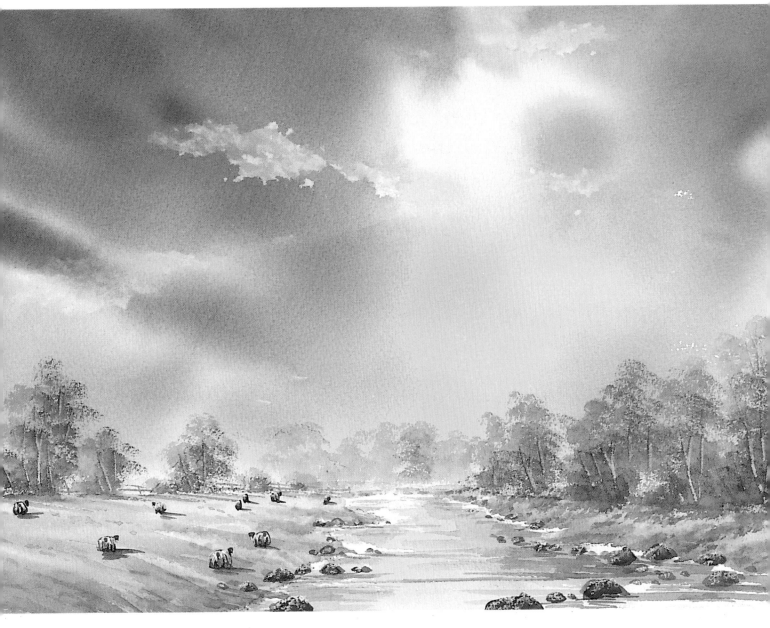

Keith Fenwick

ATMOSPHERE, MOOD and LIGHT

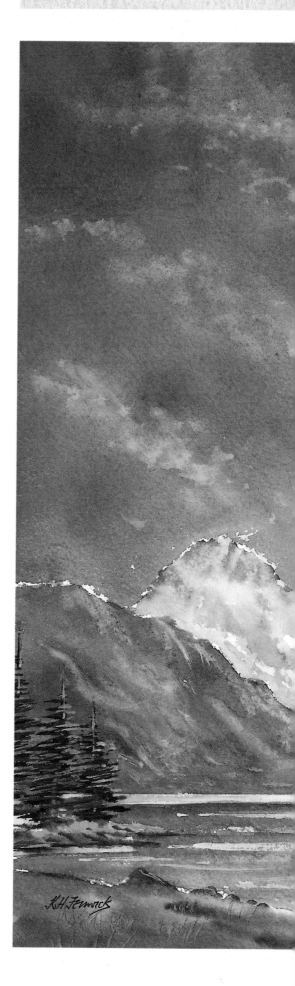

Dedication:

To Dorothy, my wife, for her support, advice and typing of the text, and to all my students over the years whose needs have helped me to determine the content of this book.

Arcturus Publishing
1–7 Shand Street, London SE1 2ES, England

Published in association with

W. Foulsham & Co. Ltd

The Publishing House, Bennetts Close, Cippenham,
Slough, Berkshire SL1 5AP

ISBN 0-572-02836-9

Copyright 2002

Printed in China

FOREWORD

The story of Winsor & Newton is one of partnership, between our founders starting in 1832 and subsequently between our company and artists. For this reason the name Winsor & Newton has become synonymous with fine art materials throughout the world. The foundation of the company stems from the development and introduction of the world's first moist watercolours in the 1830s – to this day we are justly proud of the pre-eminence around the world of our range of watercolours and materials.

Watercolour artists, from beginners to professionals, will now have the opportunity to both develop their artistic skills and their familiarity with the Winsor & Newton range through this exciting new series of techniques books, written and illustrated by the highly respected artist and instructor Keith Fenwick.

Throughout its long and successful history, the Winsor & Newton brand has developed a proud tradition of producing fine art materials of the highest quality – the company is delighted to witness the publication of a range of watercolour books that achieves similarly high levels of quality and innovation.

CONTENTS

ATMOSPHERE, MOOD and LIGHT

INTRODUCTION

Light is the single most important factor in all painting. It's the effect of light and shade that gives reality and expression to paintings; it also helps to establish structure, illuminate colour and highlight textures. The addition of shadows and the variety of tones add interest and prevent a painting looking flat.

For your paintings to work visually, you will need to draw and paint the features, capture the direction of light, vary your tonal values to emphasize the light and, of course, emulate the light itself. Light makes the landscape real and believable. Without it, the landscape wouldn't exist as we know it.

Glazing techniques are useful for creating the effects of light, but too many glazes can destroy transparency. Experience will demonstrate that the greatest source of light is the white of the paper. Atmosphere and mood add extra quality to paintings, making them special.

Skies are an important aspect in creating atmosphere and mood – after all, they can represent almost two-thirds of a painting. Skies painted using diagonal brush strokes suggest a sense of movement. Soft, fluffy cumulus clouds suggest the peace and tranquillity of a summer's day. Dark nimbus clouds are synonymous with a feeling of awe. A colourful evening sky can create a feeling of contentment.

As artists we don't necessarily paint what we see. We attempt to capture a moment in time that stirs within us, a particular feeling about a subject or landscape. In the following pages I will show you techniques and approaches you can use to translate that feeling into a finished watercolour.

Keith H Fenwick

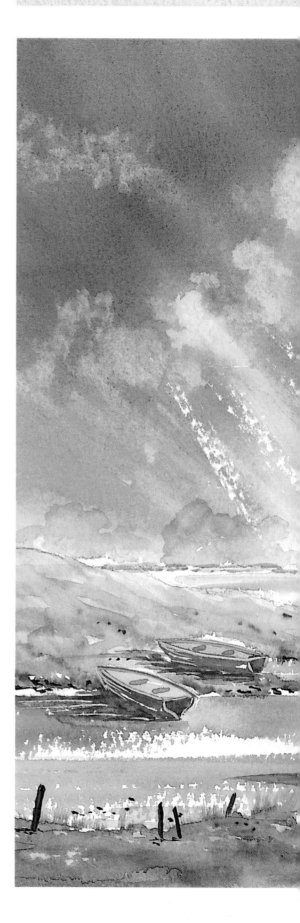

PERS

uality papers come in different forms, sizes, textures and weights. Paper
n also be purchased in gummed pads, spiral bound pads, blocks (glued
around except for an area where the sheets can be separated) and in
rying sizes and textures.

I prefer to purchase my paper in sheet form (30in x 22in) and cut it to
e appropriate size. The paintings in this book were painted on 200 or
00lb rough textured watercolour paper. When sketching outdoors, I use
iral bound pads.

Winsor & Newton offer a choice of surfaces and weights, as follows:

P (Hot pressed) has a smooth
rface, used for calligraphy and
en and wash.

OT (Cold pressed) has a slight
xture (called 'the tooth') and is
sed for traditional watercolour
aintings.

OUGH paper has a more
ronounced texture which is
onderful for large washes, tree
oliage, sparkle on water, dry
rush techniques, etc. I always use
rough textured paper.

Paper can be purchased in different
imperial weights (the weight of a
ream (500 sheets), size 30in x 22in):

90lb/190gsm is thin and light;
unless wetted and stretched, it
cockles very easily when washes
are applied.

140lb/300gsm paper doesn't need
stretching unless very heavy
washes are applied.

200lb/425gsm or 300lb/640gsm
papers are my preference.

OTHER ITEMS

The following items make up my
painting kit:

Tissues: For creating skies, applying
textures and cleaning palettes.

Mediums: Art Masking Fluid,
Permanent Masking Medium,
Granulation Medium and Lifting
Preparation are all useful and
selectively used in my paintings.

Masking tape: To control the flow
of paint, masking areas in the
painting and for fastening paper to
backing board. I prefer ¾in width as
it is easier to remove.

Cocktail sticks: Useful for applying
masking when fine lines are
required.

Grease-proof paper: For applying
masking.

Atomizer bottle: For spraying
paper with clean water or paint.

Painting board: Your board should
be 2 inches larger all round than
the size of your watercolour
painting. Always secure your paper
at each corner and each side (8
places) to prevent it cockling when
you are painting.

Eraser: A putty eraser is ideal for
removing masking.

Sponge: Natural sponges are useful
for removing colour and creating
tree foliage, texture on rocks, etc.

Water-soluble crayons: For
drawing outlines, correcting
mistakes and adding highlights.

Palette knife: For moving paint
around on the paper (see page 32).

Saucers: For mixing large washes
and pouring paint.

Hairdryer: For drying paint
between stages.

Easel and stool: I occasionally use
a lightweight easel and a stool for
outdoor work.

LIGHT *Introduction*

Artists of all generations have endeavoured to capture the magical effects of light on the landscape. Watercolour painting is ideal for this by providing contrasting tonal values and colour, wet into wet and the ability to incorporate both hard and soft edges.

Coloured glazes consisting of a small amount of paint and lots of water can easily be applied, either to warm up sections of a painting to represent sunlight or to provide contrast by applying cool colours.

It's important to realize that the white of the paper and the transparency of watercolour provide the greatest source of light in a watercolour painting. A source of light can be brightened by surrounding it with darker contrasting tones of colour. You can prove this for yourself: take a piece of waste watercolour paper, paint your light source, then paint dark tones of colour around it. If you do this your light source will appear lighter.

To begin with it's a good idea to select your subject and produce simple tonal studies to visualize the effects of light on your landscape. If you paint your subject at different times of the day, you will experience the effect changing light has on the landscape. The knowledge you get from these exercises will be invaluable for your paintings.

The colours I find most useful are shown below.

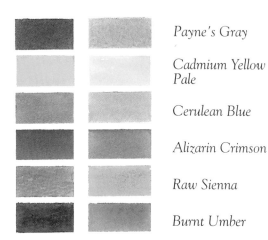

Payne's Gray

Cadmium Yellow Pale

Cerulean Blue

Alizarin Crimson

Raw Sienna

Burnt Umber

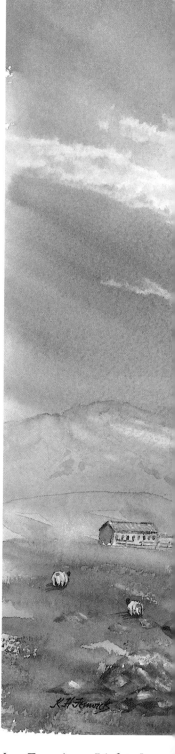

In **Evening Light** I use various tonal values in the clouds on the right and left, lighter areas surrounding the large tree, to emphasize its structure. I painted cloud shadows in the foreground to provide contrast with the soft light in the sky.

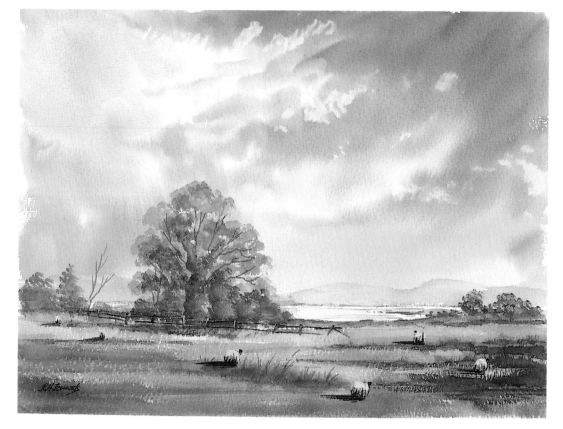

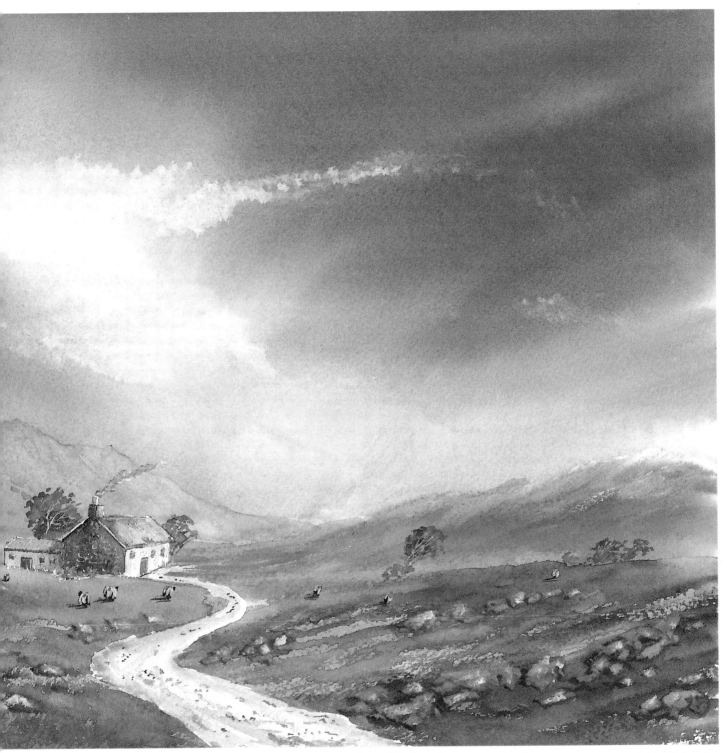

Moonlight *provides a good example of light in the landscape. The soft light radiates over the distant mountains and highlights the* *rmstead and the track, leading the viewer's eye into the painting. Masking fluid was initially applied to preserve the white of the paper* *presenting the track. Washes and detail were applied after the masking fluid was removed.*

Practice

- *Study the examples in this book and practise painting wet into wet skies to represent the various light situations.*
- *Practise colour mixing, using the colours specified in the text.*
- *Practise using an eraser to remove colour, creating shafts of light as in a woodland glade or an atmospheric sky.*

LIGHT *Colour mixing*

Colour has fascinated artists for generations. Many books have been written about this subject but there's no substitute for experience. I'm often asked by my students to divulge the percentages of each hue I have mixed together to achieve a particular colour, but I can't tell them. I just mix quantities of each colour together until I am satisfied with the outcome. Certain rules obviously have to be followe[d] If fresh clean colours are required, it's best to mix on[e o]r two colours together. For more subtle shades, m[ix] three colours together. If you mix more than thr[ee] colours you are likely to end up with a dull colou[r]. Artists call this 'mud', but there may be occasio[ns] when this is precisely what is needed.

THE BASICS OF COLOUR MIXING

The primary colours are red, yellow and blue. If similar quantities of each primary colour are mixed together the result is almost a black colour, as shown in the colour circle left. If blue and yellow are mixed together, they will produce green. Mixing red and yellow gives orange, while mixing red and blue results in a violet or purple colour. These mixtures are known as secondary colours. Tertiary colours are created by mixing a primary colour with a secondary colour; any red, yellow and blue will suffice. It's easy, as the next exercise shows.

Follow the arrows in the colour circle. By using three primary colours in the above combinations with various amounts of water, a wide range of tints can be produced. Of course, a vast range of colours can be bought, but there's nothing like experimenting with the basics to discover the range of tones you can produce.

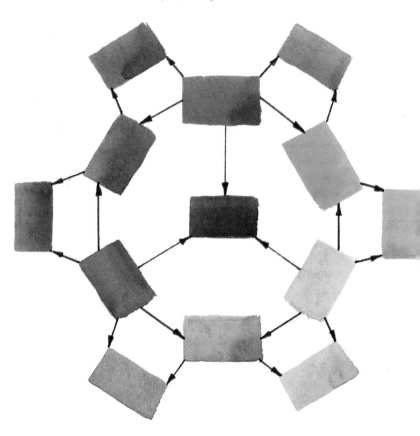

Some colour combinations I find useful are shown below.

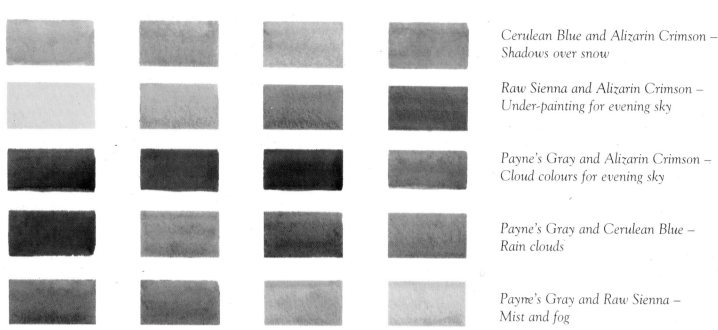

Cerulean Blue and Alizarin Crimson – Shadows over snow

Raw Sienna and Alizarin Crimson – Under-painting for evening sky

Payne's Gray and Alizarin Crimson – Cloud colours for evening sky

Payne's Gray and Cerulean Blue – Rain clouds

Payne's Gray and Raw Sienna – Mist and fog

basic palette of colours is shown below. The ginner won't go far wrong if they begin with this ection. Additional colours I use to support my basic palette are also shown below. I call these extra colours my 'supportive' palette. Occasionally, I may select further colours from the wide range available.

ic palette: Payne's Gray, Cerulean Blue, Alizarin Crimson, Raw Sienna, Burnt Sienna, Burnt Umber, Cadmium Yellow Pale, Permanent Sap Green.

bportive palette: French Ultramarine, Indanthrene Blue, Quinacridone Red, Winsor Yellow, Brown Madder Alizarin, Gold Ochre.

ayne's Gray and Alizarin Crimson – storm clouds

Alizarin Crimson and Cerulean Blue – cloud colours

ayne's Gray and Burnt Umber – storm clouds

French Ultramarine and Cadmium Yellow Pale – light in the sky

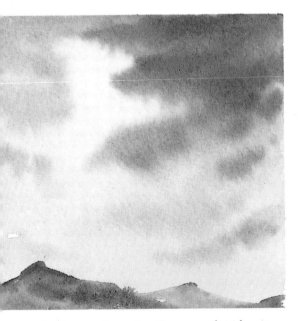

orm clouds – Payne's Gray and Alizarin rimson, painted over a pale Raw Sienna wash.

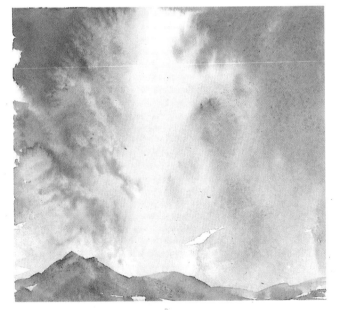

Light on the landscape – French Ultramarine on the right and French Ultramarine/Alizarin Crimson on the left, painted over a Cadmium Yellow Pale under-painting.

11

LIGHT Colour Mixing *Practice*

I've included this woodland scene, **Coat of Many Colours**, to provide you with an opportunity to practise your colour mixing. I would like you to note the variations in tone throughout this painting – this variation is important. The tree grouping on the l[] side of the painting has been painted in darker ton[] leading the eye beyond it and into the distance.

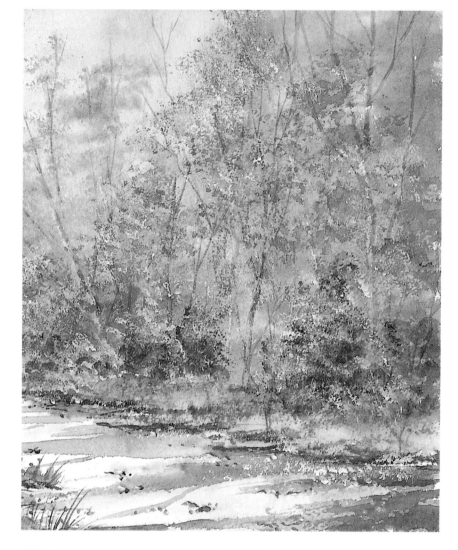

AUTUMN TREES

In this grouping you will observe a wi[] range of green and autumn tints. T[] greens have been created by using Cerule[] Blue mixed with Cadmium Yellow Pale a[] Raw Sienna. The autumn hues have be[] mixed using combinations of Raw Sienr[] Burnt Sienna and Alizarin Crimson.

Trees and bushes appear dark on t[] inside and become lighter towards t[] extremities. To capture this depth in t[] foliage, I over-painted with dark tones [] Payne's Gray mixed with a little Aliza[] Crimson when the under-painting w[] completely dry, producing a dark mau[] colour. Never use black for this purpose – really kills a painting.

The tree structures were painted using[] weak Burnt Umber, followed by stippling [] the foliage with a small, artist's spong[] incorporating suitable autumn colou[] Before you try this, practise first on [] similarly textured piece of watercolo[] paper.

ADDING DARKER TONES

To create the foliage on the left-hand tree[] I applied a wide range of greens in varyir[] tones, mixed from Cerulean Blue, Cadmiu[] Yellow and Raw Sienna. To paint the foliag[] I stippled with the sponge dipped in pair[] pre-mixed on my palette. When this w[] completely dry, I over-stippled with da[] tones of a Payne's Gray/Alizarin Crimson m[] to create depth in the foliage. Depth is s[] necessary to the success of a painting suc[] as this, because it leads the eye beyond th[] darker tree grouping into the distance. Th[] concept or design principle is known [] 'recession'.

When the paint was dry I added som[] white gouache paint to the green mixtur[] to lighten them. Using the stipplin[] technique, I added a few highlights in th[] foliage to retain the overall impression [] depth.

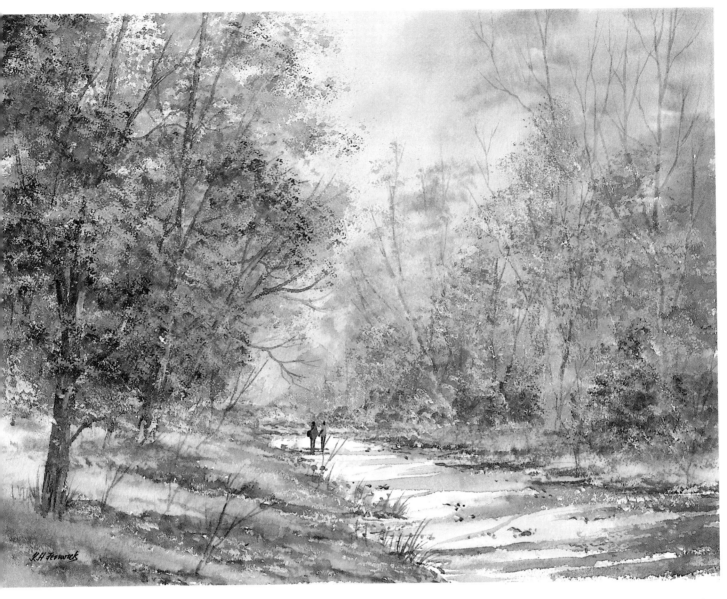

EXTURE

our painting can be made more realistic by dding texture to the grassy areas. This is achieved y applying initial washes of a soft pale yellow in he distance, followed by green to selected areas. Vhen the paint is approximately half dry, the edge f a hake (the tip of the brush should be brought lmost to a chisel edge) is used to paint in some larker tones to represent texture; loading the rush with a Payne's Gray/Alizarin Crimson mix is deal for this. You must touch the paper lightly to leposit paint, then, using the corner of the brush, lick upwards to create tufts of grass. It's a very imple technique.

The walkers are important in this painting – hey're the focal point, leading your eye down the ath. Don't forget to paint some shadows across he footpath.

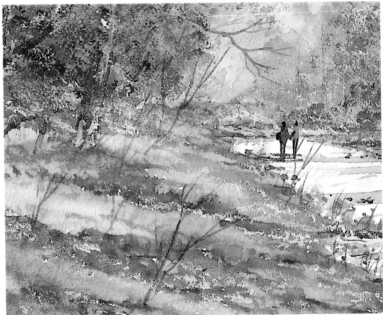

LIGHT *Design considerations*

When I first began painting, I often completed paintings that looked boring although drawn correctly and well designed. After studying works of art in national galleries, I soon realized that my paintings needed light to give them life. Light is the single most important factor in all paintings.

When I'm unhappy with a painting, I will shine a powerful torch over it to determine whether making areas lighter will improve my representation. Then I wash out the colour with a sponge and dab it with a tissue until I feel I've created the effect I'm looking for. Try this technique – it works.

Although I still use this technique, I attempt to plan for it before I apply paint. Paintings don't just happen, they have to be designed. Keep the following points in mind when you are planning your painting.

Points to Remember

1. In early morning light, shadows are ill-defined, the elements lack sharpness and colours have a bluish appearance.

2. When the sun is setting every feature in the landscape – eg, buildings, trees, etc – will appear as silhouettes against the sky.

3. Glazes can be applied to warm certain areas of a painting to represent sunlight.

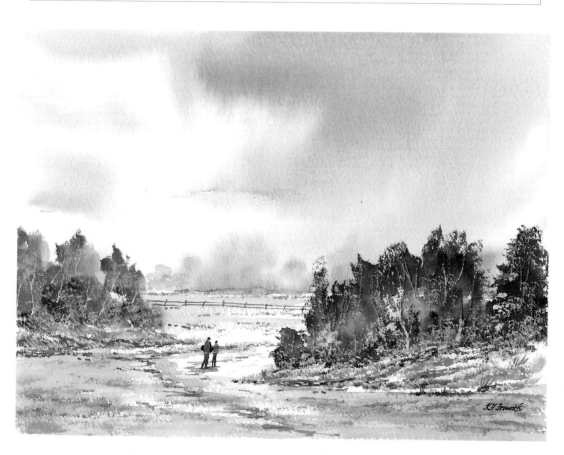

Winter's Majesty is a ve[r]y simple exercise for you to tr[y.] Note the cold winter sky, t[he] splashes of colour in the folia[ge] and the sense of recession achieved by painting the f[ar] distant trees in pale coo[l] colours wet into wet. Observ[e] the subtle sky shadows in th[e] snow and the impression o[f] stubble here and there. Th[e] figures are the focal point. Th[e] tree structures were scratche[d] out with a palette knife an[d a] cocktail stick when the pain[t] was one-third dry.

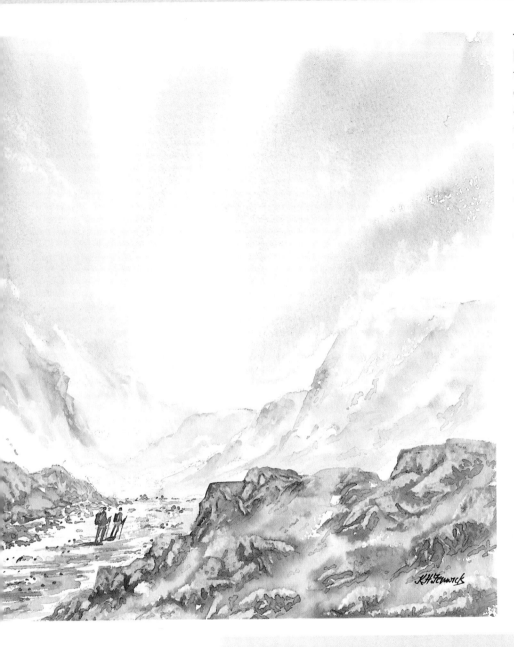

There's something special about light attempting to show through the diffused background of early morning mist. The atmospheric effect makes it difficult to see the real colours of objects in the distance.

In the middle distance, colours appear bluer, less sharply defined and lighter in tone, no matter how much light there is. As we approach the foreground the elements appear sharper and darker in tone than they do in the distance. Although their true colours are displayed, foreground objects can appear simply as silhouettes if the distant light is bright.

In **The Hikers** *the principles of design we addressed above are clearly represented. The light is attempting to break through the mist and the distant mountains are diffused and cool in colour. The path leads the eye into the painting and the hikers become the focal point. More detail has been painted in the foreground, with the rocks created by outlining their shape with brushwork and their structure scratched out with a palette knife.*

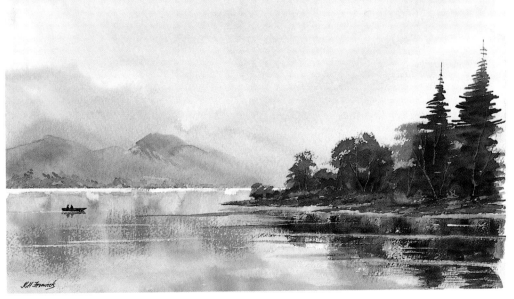

Autumn on the Lake *was a simple sketch produced in six minutes. The group of trees is virtually a silhouette, but colour reflects across the loch as the sun rises above the distant mountains. This is a useful exercise for a beginner.*

LIGHT *Early morning*

Here are three different examples of early morning light: first light as dawn breaks; a back-lit subject where the light has broken through the clouds, creating a gl over distant mountains; and a front-lit woodland sce

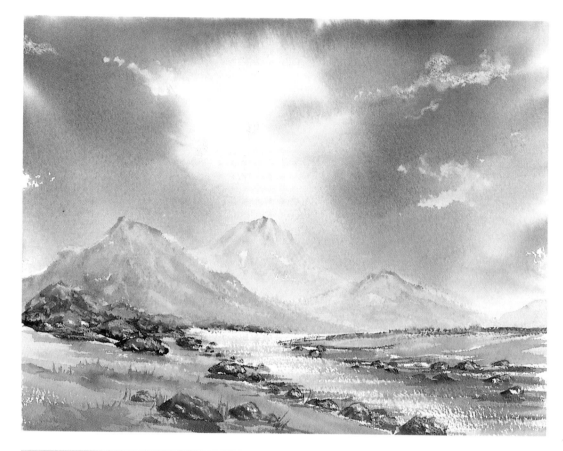

Skylight is a fine example early morning sun break through the clouds, lighting up landscape. The distant mount seems to sparkle, as does surface of the water. The sky is main feature in this painti although it was painted in less th three minutes. Initially, I pain a circle of Cadmium Yellow Pa While the paper was flat, I paint French Ultramarine on the rig hand side and a Payn Gray/Alizarin Crimson mix the left.

Using a spray bottle, I spray water in the centre of t Cadmium Yellow Pale and, lifti up the board, tilted the paper allow the colours to run different directions and ble together. An occasional spray he and there encouraged the paint flow freely. When I was satisfi with the cloud formation, I laid t board perfectly flat to allow t paint to dry. When approximate one-third dry, I used an absorbe tissue to add a few white clouds

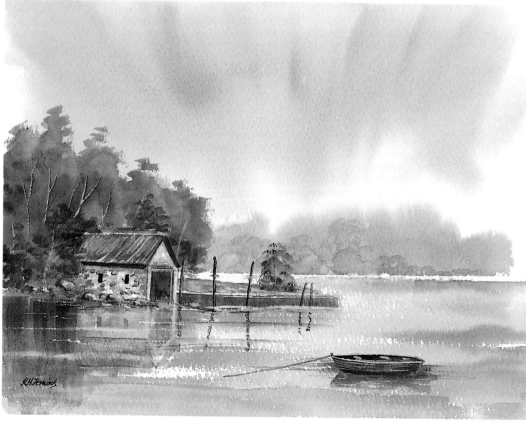

Boathouse was painted at t first light of dawn. The bac ground is a simple wash varying light tones of Payn Gray over a weak Raw Sien under-painting. The distant tre were painted wet into wet achieve a soft diffused look. T foreground trees are in silhouett The red roof of the boathouse quite dull, as is the pale coloure stonework. The lake surfa reflects the colours of the sky ar the water on the left-hand side in shadow from the dark tre grouping. The boat was added give a splash of colour to th otherwise dull scene.

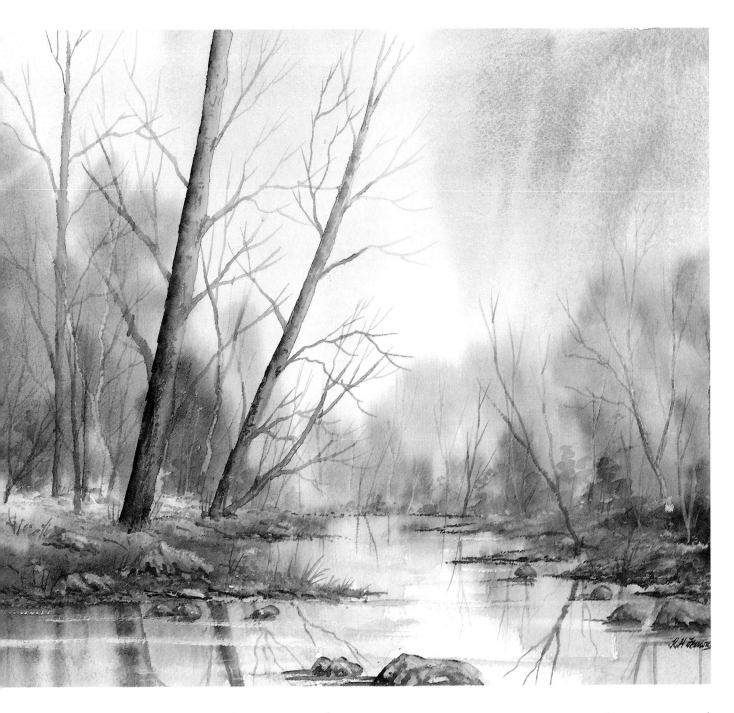

ver Rhapsody is the type of scene I love to paint. The ·dued early morning light was behind me, attempting to break ough the early morning mist. The far distant trees can barely seen and blurred images of the trees in the middle distance vide a background to the large trees on the left.

It's autumn, the leaves have fallen, allowing the structure of trees to be visible. Distant tree structures were scratched out h the palette knife. If the paint is too wet when scratched out ·ill run back, resulting in a dark tree structure. The trick is ·eave the paint until it is about one-third dry, when a pleasing ·t tree structure will result. In this painting some structures light and others dark.

The trunks of the large trees in the foreground were painted in dark tones of brown and a tissue shaped to a point wiped down to remove paint, lightening the right-hand side of the trunks. A rigger brush was used to paint some dark tones on the trunks, making them look round. The branches were added – also using a rigger brush – and a few reflections painted in the water.

Very important in this painting are the contrasts of pale tones and colours representing the soft, diffused early morning atmosphere.

LIGHT *Evening*

Evening is probably my favourite time to paint. The landscape is going to sleep. It's so peaceful, a time for contemplation. The clouds have darkened, contrasting with the light in the sky, making the light appear even brighter. The sky colours are reflected the surface of the water, creating a sense of pe. and tranquillity.

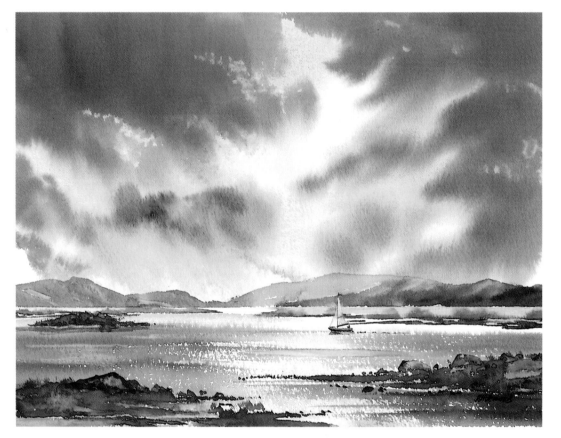

In **Lone Sailor** the silhoue of the foreground rocks and sailor contrast with the fa light.

I want you to use y imagination to try to capture scene in paint. Don't try to c the colours I have used exac Use them only as guides. M the painting your own. H some fun with it.

Soft Light contrasts with the painting above, the light soft and diffused, providing a glowing background to this autumn scene. I painted the sky by initially applying a pale Raw Sienna wash to wet the whole of the painting. In the sky, I brushed in soft purple mixes made from Payne's Gray and Alizarin Crimson, adding lots of water to produce the pastel colours. While the paint was still wet, I brushed in some pale grey to represent distant trees.

The ivy covering the base of the trees was painted by stippling various green tones with a round headed hog-hair brush. This brush was also used to stipple in the foreground texture after the initial wash had dried. (For detailed instructions on painting tree structures, see page 43.)

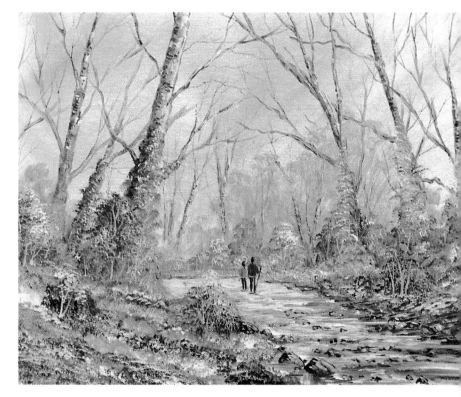

...sea is calm, the day's fishing is over and the light is ...ckly fading. The scene depicted in **Resting** was ...pleted in 40 minutes on the coastal road near Mallaig in ...tland.

...An initial Raw Sienna wash was applied to the sky area ...a hake brush. I added a little Alizarin Crimson as I ...ked towards the horizon. When the under-painting was ...roximately one-third dry, the clouds were painted using ...es of Payne's Gray and Alizarin Crimson. The same ...urs were used to paint the water.

...The boat was added to balance the darker cloud ...nations in the left-hand side of the painting, but it's the ...that establishes the atmosphere and mood.

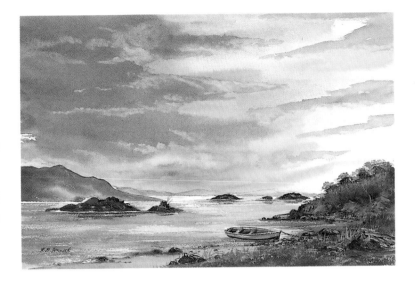

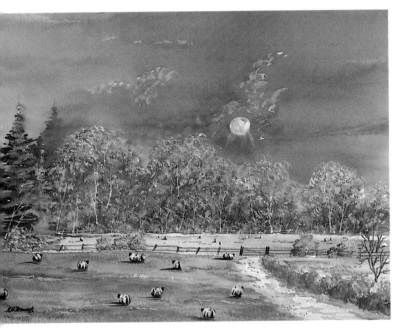

The treetops and a distant field are illuminated in **Moonlight**. I began by painting the full moon with masking fluid. When this was completely dry, I painted the sky by wetting the paper with clean water, using the hake brush, and followed this with washes of French Ultramarine with a little Alizarin Crimson added. A tissue was used to create a few white cloud shapes. When the rest of the painting was completed, the masking was removed and the shadows on the moon were painted. Note that the path was painted by retaining the white of the paper and adding a little colour here and there. It's an important feature, leading the eye into the painting and up to the moon.

...alk on the Beach shows a glorious sky lighting up ...landscape. I used a range of colours to capture it. ...addition to soft Cerulean Blue and Raw Sienna, ...h a touch of Gold Ochre for the under-painting, I ...d a combination of Payne's Gray/Cerulean Blue ...d Burnt Sienna for the clouds. A tissue was used to ...ten the edges and create a few white clouds. The sea ...s painted with a hake brush. I painted the rocks ...tially by applying washes and then created the shapes ...moving paint with a palette knife. Note the shadows ...er the sand – such little touches improve a painting.

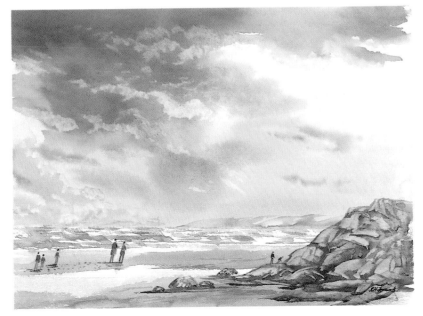

LIGHT *Project*

The scene depicted in **The Garden in Bloom** is one that I felt I just had to paint, as a reminder of my visit to Bodnant Gardens in Wales. The soft blue sky contrasted beautifully with the colourful azaleas and rhododendrons. I remember sitting on a seat, think how peaceful it was. The painting provided opportunity to use some imaginative techniques achieve the end result.

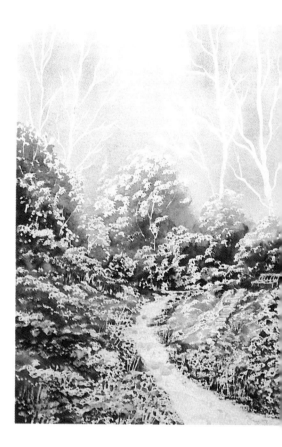

1. DRAWING AND MASKING

I drew a rough outline with a dark brown water-soluble crayon a. using masking fluid, masked the tree structures using a twig for i trunks and a cocktail stick for the finer lines. These tools we disposable, which saved me the effort of having to remove i masking from brushes. I used a stippling action with a crump piece of grease-proof paper dipped in the fluid to mask the folia. To paint the sky, I poured a Cerulean Blue wash over the ar followed by a Permanent Sap Green wash over the areas of folia. Both of these washes were pre-mixed in ceramic saucers.

2. BUILDING UP TONE

In order to represent shadows in the foliage, I waited until the washes in stage 1 had completely dried and then poured a dark tone of pre-mixed Permanent Sap Green/Burnt Umber over the lower half of the painting.

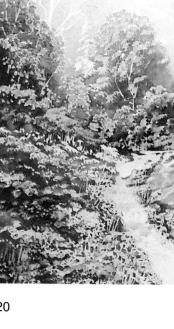

3. REMOVING MASKING AND PAINTING THE BUSHES

After removing the masking from the trees and bushes above t bridge by means of a putty eraser, I painted in representations azaleas and rhododendrons. The colours I used were mixes of Ra Sienna, Cadmium Yellow Pale, Alizarin Crimson and Burnt Sienn applied with a size 6 round brush.

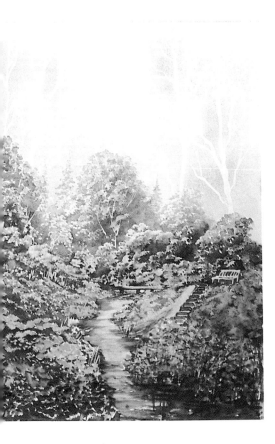

4. REMOVING MASKING, PAINTING FLOWERS AND WATER

The masking was removed from the lower half of the painting and the flowers painted with mixes of French Ultramarine, Alizarin Crimson, Raw Sienna, Cadmium Yellow Pale, Burnt Sienna and Payne's Gray. Payne's Gray and Alizarin Crimson provided a darker tone as shadows in the foreground bushes. The stream was painted using various tones of a Cerulean Blue/Payne's Gray mix.

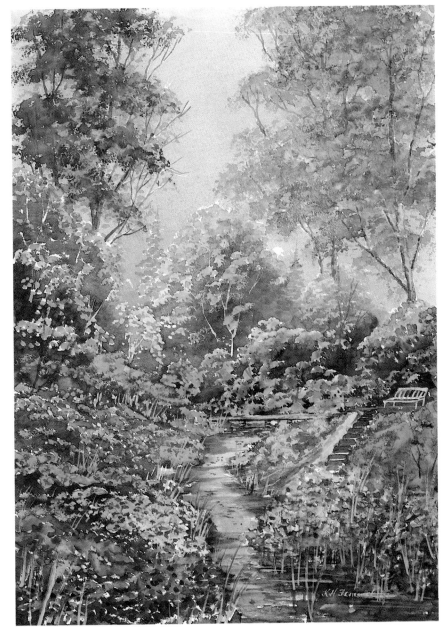

5. FINAL STAGE

To complete this painting the background trees were added, using darker tones of green for the left-hand tree and lighter tones for the right-hand tree. A range of soft yellow greens and darker greens were mixed using Cadmium Yellow Pale and Permanent Sap Green. A natural sponge dipped in the mixes was used to stipple in the foliage. A rigger brush loaded with Burnt Umber was used to paint in the tree structures.

The colours used

| Payne's Gray | Cerulean Blue | Alizarin Crimson | Raw Sienna | Burnt Umber | Cadmium Yellow Pale | Permanent Sap Green | Burnt Sienna |

ATMOSPHERE AND MOOD *Introduction*

There's an old saying that 'labourers work with their hands, craftsmen work with their hands and their head, and artists work with their hands, head and *heart*.' This is particularly relevant when creating atmosphere and mood.

Emotions can be stirred by a fast-flowing river, the beauty of falling snow, the effect of light, children playing on a beach or the excitement of colour in a landscape.

Creating atmosphere and mood isn't just attempting to capture a sense of drama such as wind-blown clouds over a dominant mountain structure. It may be a sense of peace and tranquillity, a pastoral scene or the shape of trees in a particular setting. It's what stirs our emotions and provides us with a sense of excitement, contentment, fascination or awe.

It's the artist's role to attempt to capture that special moment in time, using the tools at his disposal.

Diagonal lines provide a sense of movement, as in a wind-blown sky. Vertical lines suggest a sense of awe and power, such as in tall buildings or high mountains. Horizontal lines suggest a pastoral scene. An atmospheric effect can be subtle or bold but the overall effect should be representative of the place you are painting and sympathetic to nature.

In the following pages, I'm going to show you how to paint a wide range of atmospheric effects and encourage you to use your imagination to create paintings that will give you many years of pleasure and satisfaction.

Painting is rather like making a cake – gather all the ingredients together in the best mix and create your masterpiece.

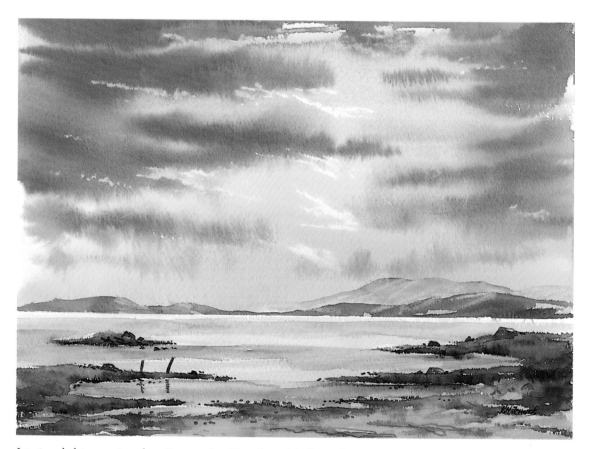

*I painted this evening sky, **From the Road to Mallaig**, by initially applying a Cerulean Blue wash at the top and adding a Raw Sienna/Alizarin Crimson mix as I approached the horizon. When the under-painting was approximately one-third dry, the clouds were painted, using the hake brush loaded with a dark toned Payne's Gray/Alizarin Crimson mix.*

Points to remember

- *Try to create a wide range of atmospheric effects.*
- *Use your imagination.*

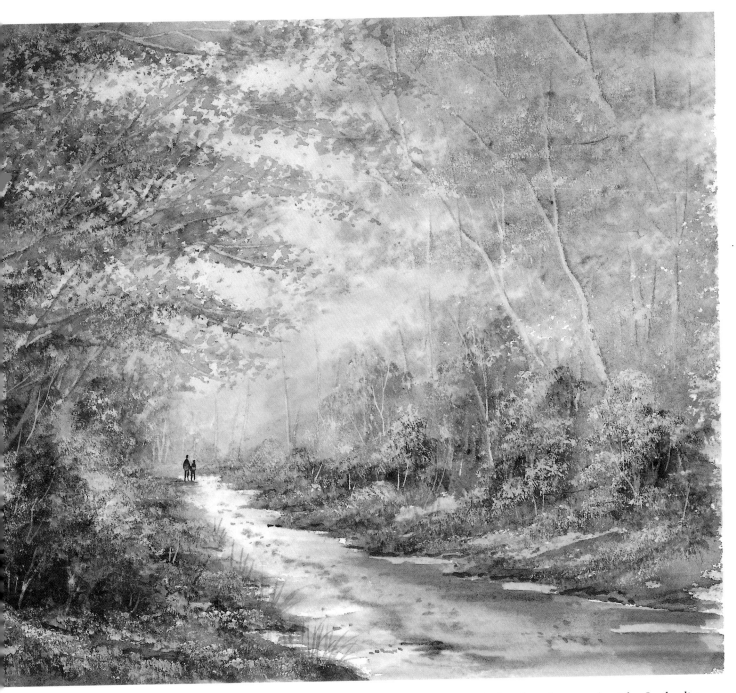

The tonal values on the left side of this typical woodland path in **Green Harmony** are darker than those on the right. In the distance the colours are paler and cooler, taking the viewer's eye down the path into the painting. The walkers are the focal point and have been placed to direct the eye.

The colours used

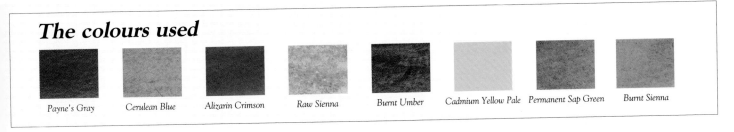

Payne's Gray Cerulean Blue Alizarin Crimson Raw Sienna Burnt Umber Cadmium Yellow Pale Permanent Sap Green Burnt Sienna

ATMOSPHERE AND MOOD *The effect of light*

It can be an informative and enjoyable experience to paint the same scene at different times of the day. The changing light has significant effects on the landscape, creating contrasts in atmosphere and mood. Compare these paintings of the same scene early morning, at midday and in early evening.

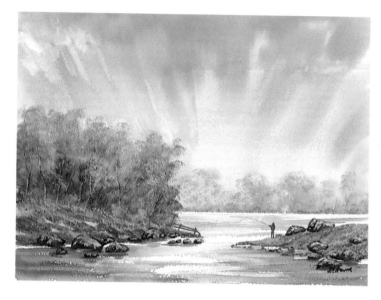

Early Morning *Blue-green mixes and simple washes were used here to clearly define the time of day.*

The shadows are ill-defined, and the subtle distinction between the elements lack sharpness. The colours tend to a blue-green and there's a suggestion of mist that will quickly disappear as the sun rises.

I painted a wet into wet sky, using Cerulean Blue, and added a weak Permanent Sap Green to the blue to paint the distant trees. Various tones of these two colours were used to paint the foreground trees and bushes, the land and also the water.

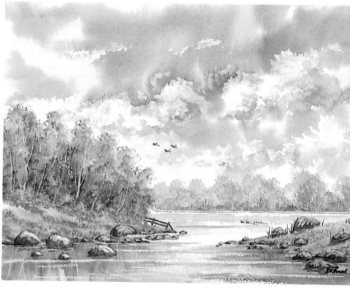

Midday *The clarity of this landscape suggests that it's noon. Any early morning mist has been burnt off by the warmth of the sun. A division between the lights and darks can easily be seen. There's a greater contrast in colours and tones because the light is stronger.*

I used combinations of French Ultramarine, Cadmium Yellow Pale, Raw Sienna and a Payne's Gray for the trees and painted warmer colours in the land areas. The sunlight is reflected in the water.

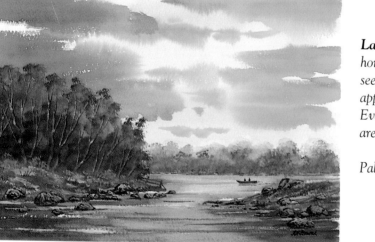

Late Evening *The sun is beginning to set. The elements are silhouetted against the warmth of the sky and there's less detail to be seen. The water reflects the colours of the sky. Night is rapidly approaching. In a short time the landscape will fade into darkness. Everything is at rest; the birds have gone to roost and the fishermen are enjoying peace and quiet, away from the stresses of life.*

The colours I used to paint this scene were Cadmium Yellow Pale, Raw Sienna, Alizarin Crimson and Burnt Umber.

\ERCISES

*Select a local scene, within your present
\mpetence level, and paint it at different times of the
\y. Make notes of the principal differences in terms of
\ht, cloud structures, colour contrasts, tonal values
\d sharpness.*

*Take lots of photographs of interesting cloud
\rmations to build up a resource from which you can
\aw as and when required.*

- *Study the effect rain clouds have on the colours in
the landscape.*

- *Choose a landscape painting in this book and paint
it as if it were a depiction of another season.*

- *Practise painting sheep, figures and boats.*

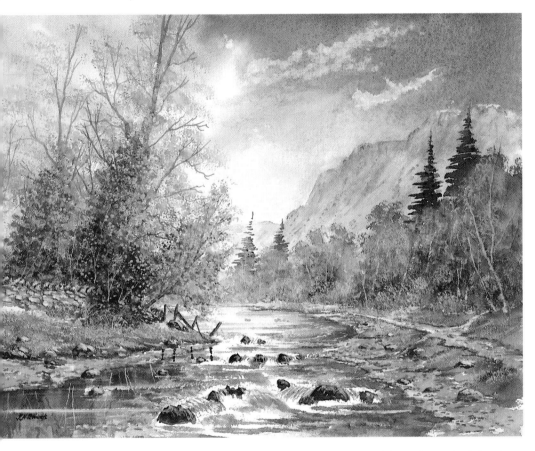

Autumn Light *depicts the
changing colours of autumn.
Note the variety of colours in
the foliage and the effect of light
in the atmospheric sky radiating
over the mountain range.*

*Because this is a back-lit
subject, shadows are cast in the
water.*

Points to remember

- *An atmospheric effect can be subtle or bold, but the
overall impression should be representative of the
region and sympathetic to nature.*
- *When painting early morning, shadows are ill-defined
and the subtle distinctions between the elements
lack sharpness.*
- *In the evening shapes become silhouettes against a
soft, warm sky.*
- *The sky sets the scene in a painting, creating
atmosphere and mood.*

- *Fog and mist cast a veil over distant objects; colours
are softened and the elements appear diffused.
Distant fog or mist can be emphasized by adding in
the foreground a little more detail and colour than
can actually be seen.*
- *When painting snow always establish the value
relationships between the sky and its reflections in
the snow.*
- *To paint rain, apply a wet initial wash, paint in the
cloud colours, lift the board and tilt it to encourage
the paint to run in the direction required. When you
are satisfied with the result, lay the board flat and
allow the paint to dry naturally.*

ATMOSPHERE AND MOOD *Skies and rain clouds*

The sky establishes the atmosphere and mood in a painting. The effects of light in the landscape are vital to bring your watercolours to life. Don't forget that practice makes perfect – you're not expected to get it right first time.

When I want to emphasize the effects of light in the landscape and to help me create atmosphere and mood, I will take photographs that go against the usual conventions of photography. Rather than having the sun behind me as convention dictates will shoot looking directly into the sun. T photographs will print much darker but t contrasting lights and darks will be very distinctive will use different camera settings, and then assess t results.

Try this approach for yourself. When you come apply paint to your subject, it will be up to you create the atmosphere and mood you want.

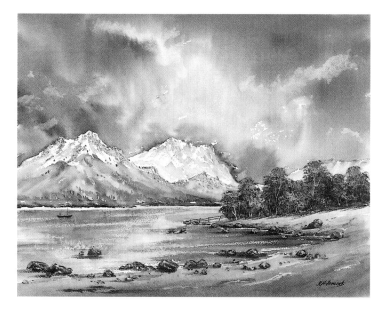

The sky in **Scottish Loch** *was painted with the same technique as that used in* **Snow Capped**. *The colours used were Raw Sienna, French Ultramarine and Alizarin Crimson.*

Snow Capped *is a dramatic sky painted with a hake brush. circle of Cadmium Yellow Pale was painted to represent li radiating from the sun. Mixes of Cerulean Blue/Payne's G and Alizarin Crimson were used to paint various tones of col in the sky. While the paint was still very wet the paper was til to allow the colours to flow and blend together.*

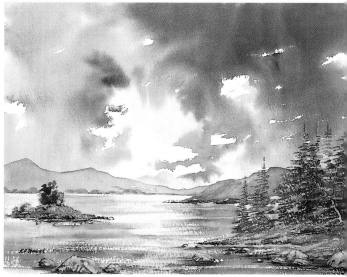

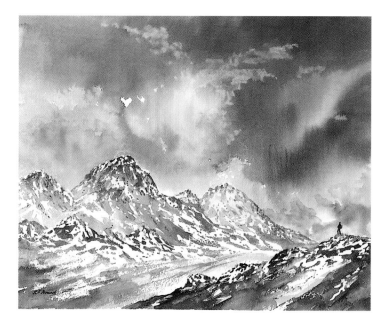

The dramatic sky in **Not Quite There** *was painted in less th four minutes. A greater variety of colours and tones was used this sky study than for the other two shown on this page: R Sienna for the under-painting, followed by Cerulean/Fren Ultramarine mixes and Payne's Gray/Alizarin Crimson to cre the darker tones. A few white clouds were created by remov paint with an absorbent tissue.*

sky full of rain is possibly the easiest type to paint with watercolours. Attach your watercolour paper to board and lay it flat, apply a very wet wash of a pale tone of Cerulean Blue or Raw Sienna and, while the paper is still very wet, brush in dark tones of Payne's Gray mixed with Raw Sienna, Burnt Umber or Alizarin Crimson at the top of your paper. Immediately, lift up the board and paper and, holding them almost vertical, tilt them in the direction required to encourage the paint to flow. Watch the result as you do this, and once the paint has run sufficiently to create the effect you're looking for, lay the paper perfectly flat and let the paint dry naturally. Use a tissue to soak up any unwanted pools of colour at the bottom of the sky. It's as easy as that.

This technique was used for both of the paintings shown below.

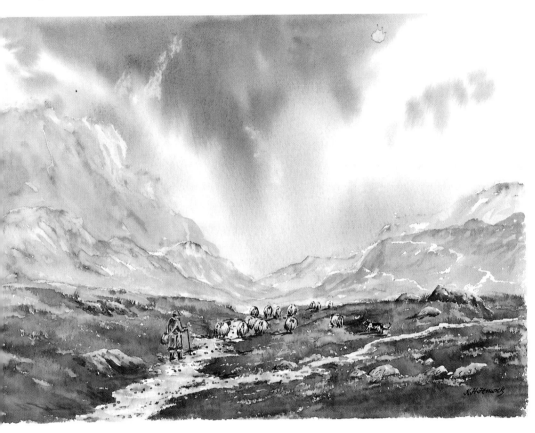

Homeward Bound was started in the English Lake District while my wife held an umbrella over me. Such weather conditions encourage speedy work.

For the sky, I quickly brushed in a weak Cerulean Blue and added a little Raw Sienna in selected areas, followed by a Payne's Gray/Raw Sienna mix. The shepherd and sheep were painted in my studio later.

The House on the Moor offers you an opportunity to practise the technique I use for depicting a rainy landscape. Although the technique is very easy, timing is important. Only experience through practice will teach you how to get this right.

To paint the sky, wet the area initially with a weak Raw Sienna or Cerulean Blue, and use a mix of Payne's Gray/Raw Sienna for the clouds.

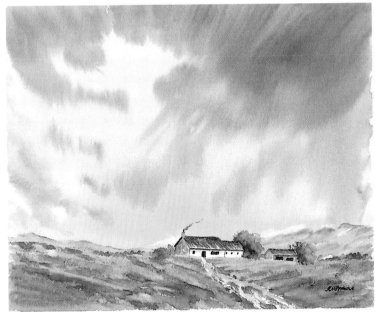

ATMOSPHERE AND MOOD *Close up*

Wet and Windy is full of atmosphere and mood. The rain is streaking down. The distant mountains are barely discernible through the torrential rain and this gives them a ghostly appearance. It's not the day to be out and about. The smoke from the chimney indicates that those living in the croft are of the same opinion. I think you will enjoy painting this scene.

THE SKY

I fastened the paper to the board and laid it flat before painting the rain clouds. I used a hake brush to apply a very wet Cerulean Blue wash to the whole of the sky area. While the under-painting was still wet, a strong mix of Payne's Gray with a little Burnt Umber added was brushed into the top of the sky. The board was immediately lifted and angled vertically to allow the paint to run down the paper. Once the desired effect was achieved the board was laid perfectly flat and the paint left to dry naturally.

MOUNTAINS AND BUILDINGS

I fastened the paper to the board and laid it flat before painting the rain clouds. I used a hake brush to apply a very wet Cerulean Blue wash to the whole of the sky area. While the under-painting was still wet, a strong mix of Payne's Gray with a little Burnt Umber added was brushed into the top of the sky. The board was immediately lifted and angled vertically to allow the paint to run down the paper. Once the desired effect was achieved the board was laid perfectly flat and the paint left to dry naturally.

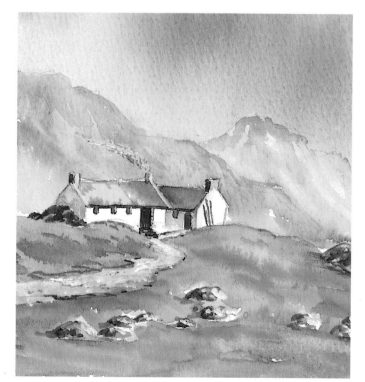

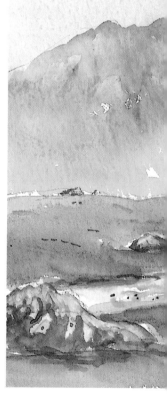

Atmosphere

In this painting the atmosphere is created almost entirely by the rain clouds and their effect on the landscape.

28

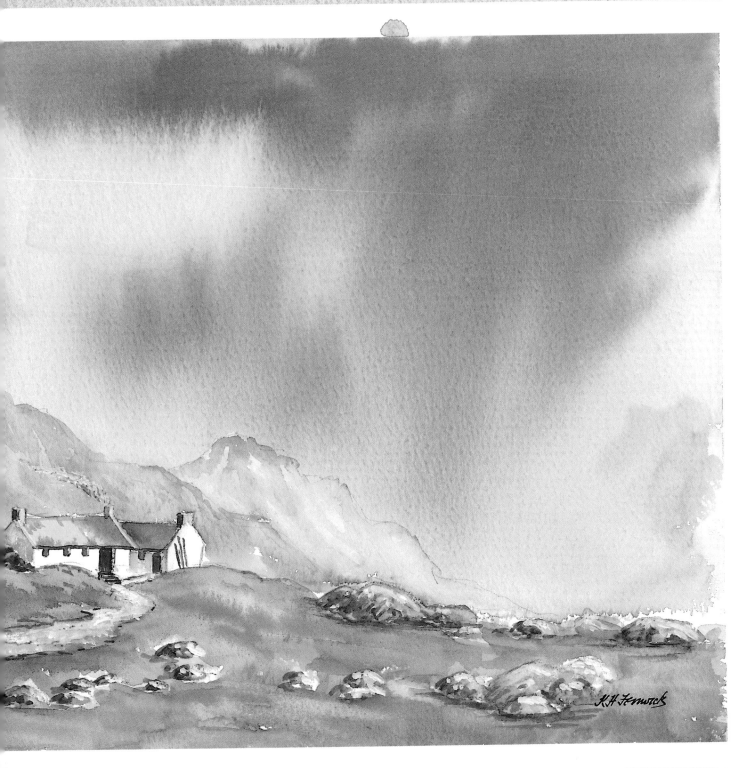

OCKS

After removing the masking the rocks were painted using Raw Sienna as an under-painting and Payne's Gray/Burnt Umber for the shadows. Highlights were made by removing paint from the tops of the rocks with a tissue rolled to a point. Dark shadows were painted under the rocks to make them look more realistic.

ATMOSPHERE AND MOOD *Mist, fog and snow*

Fog and mist cast a veil over objects in the distance and colours appear soft and diffused. It's important to keep distant values light in tone and add a little more colour and definition in the foreground. The foreground must be more sharply focussed than appears in reality to give emphasis to the mist or fo in the background

*The sky for **Lakeside** was painted wet into wet, by applying a weak Cerulean Blue wash and brushing in some Alizarin Crimson. I continued working downwards and painted the water using the same colours. While the paint was still wet, I painted the distant mountains and the trees in the middle distance, wet into wet, to achieve a soft diffused look. The fir trees were painted with a stiffer Permanent Sap Green, then I used a tissue to remove some colour and soften the tree grouping. Reflections using very pale colours were added to the water while the paint was still wet. When the paint was dry the land and rocks in the foreground were painted in more detail to lead the viewer's eye into the painting.*

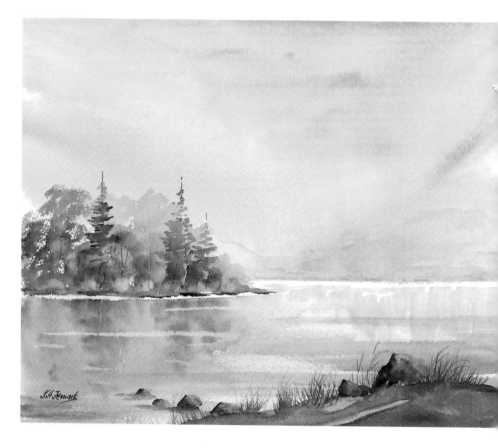

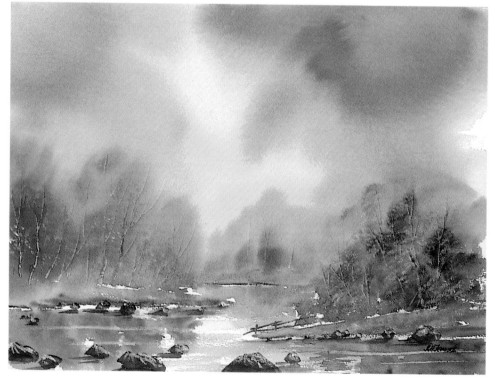

Mist on the River depicts an early morning scene, with the sun struggling to shine through the mist. The sketch has been painted wet into wet to achieve the soft filtered light effect that is so necessary when painting mist o fog. My aim was to create a hazy atmospheric effect. The colours used were Cadmium Yellow Pale, Raw Sienna, Payne's Gray, Alizarin Crimson, Cerulean Blue and Burnt Sienna.

hen painting snow it's important to establish the value relationships between the snow and the sky. now isn't always white, just as the sky is not always pretty blue. Leave the paper untouched for the hitest snow. The washes used for the sky can be ansferred to the snow area to create the shadows flected from passing clouds.

Snow scenes don't have to look cold. You can use ft washes of Cerulean Blue for a cold scene, a purple hue made from Payne's Gray or French Ultramarine and Alizarin Crimson for a slightly warmer effect, and for warmer sunlit snow you can apply a Raw Sienna glaze over a blue or purple under-painting. Show some stubble, tufts of grass or even the odd rock protruding through the snow to add interest.

In the following two examples, you'll notice how important are the skies to the success of the paintings.

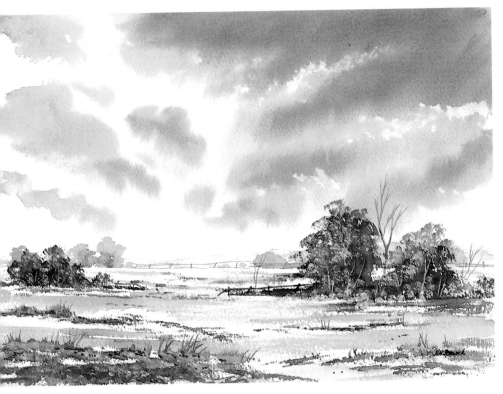

Early Snow depicts the first coating of snow on the landscape. The subject is back-lit; I have painted a little Raw Sienna into the sky to reflect this, and have also transferred some of this colour into the snow lying on the fields. Note how I have achieved recession by painting the trees and bushes in the far distance in cooler pale tones.

To paint the stubble and vegetation showing through the light covering of snow, I used the edge of a hake brush, touching the paper lightly with an upward flicking motion.

n **On Thurstaston Hill**, a avourite beauty spot in the Wirral, vhere I live, I have used the sky colours of Payne's Gray and Alizarin Crimson to paint the path and the pool of water on the right. This was mportant to achieve colour harmony in the scene. The white of he paper has been left uncovered o represent snow at ground level. I used a little white acrylic paint to stipple the effects of snow on the trees and foreground gorse bushes.

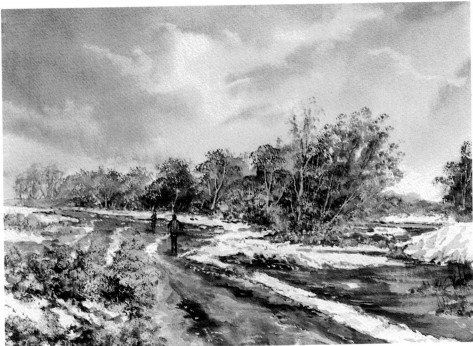

ATMOSPHERE AND MOOD *Close up*

There's nothing quite like a walk in the woods on a crisp winter's day. Nature in all its glory is a joy to behold. **Woodland Walk** is one such scene, providing the opportunity to incorporate a soft atmospheric sky, a wide variation in the colours of winter and the effects of a light dusting of snow on the landscape. This is the type of scene I love to paint. I used acrylic watercolours to paint it.

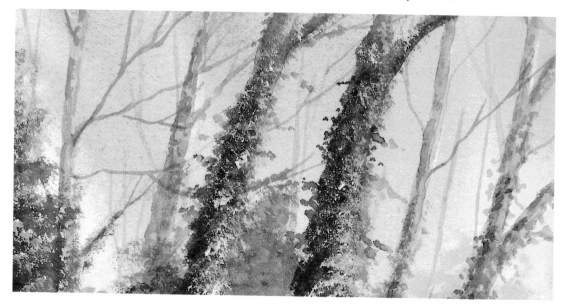

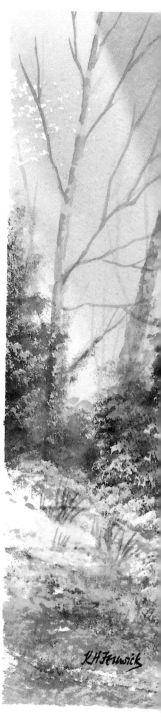

SKY AND IVY

I painted the sky by initially applying a pale Raw Sienna wash over the sky area with a hake brush. Using downward strokes, I then brushed in Cerulean Blue, starting on the left and gradually changing to a soft purple as I worked my way across to the right of the painting. I left some of the Raw Sienna uncovered to represent the sun breaking through a diffused background. When the paint was approximately one-third dry, I painted the distant trees, using a stiffer mix of Payne's Gray/Permanent Sap Green to achieve a blurred effect to lead the viewer's eye into the distance.

The ivy on the trees was painted with a hog-hair brush using a stippling technique; dark tones of Burnt Umber/Permanent Sap Green were applied, followed by a paler, brighter green and finally white acrylic paint stippled on to give the effect of snow.

TREES AND SHADOWS

Using a rigger brush, the trunks and branches were initially painted with pale Raw Sienna. When the paint was approximately one-third dry, some dark tones of Burnt Umber were added to make the branches look realistic. The soft purple mix for the sky was also used to paint the shadows on the path, using the side of the round brush.

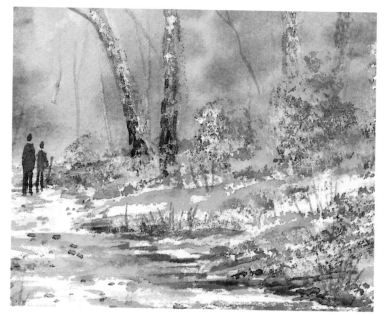

Snow

Using white acrylic paint is only one way of representing snow. There are other techniques – *see page 31.*

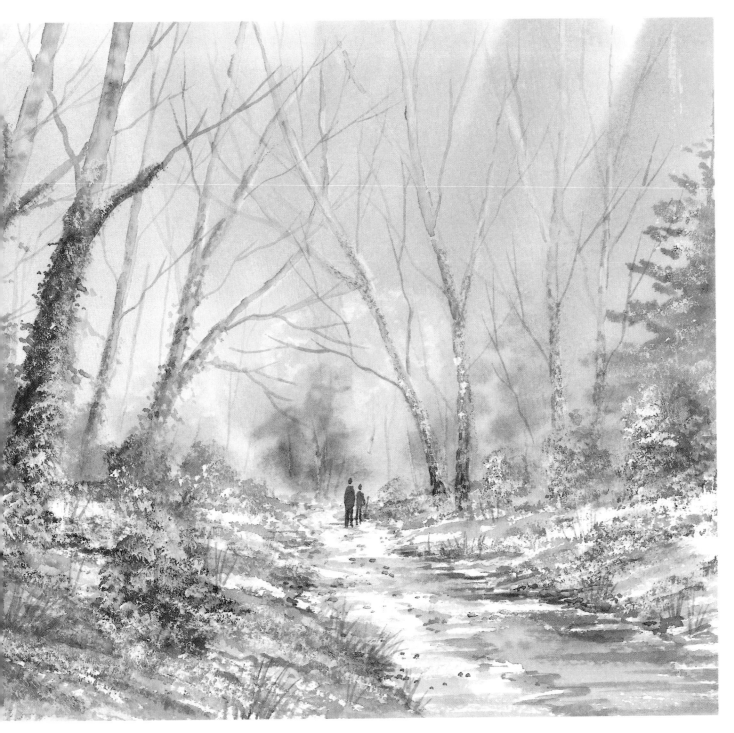

OREGROUND TEXTURE

...lightly stippled a variety of colours ...sing the edge of a hake brush, and ...ft some white of the paper ...ncovered. I applied soft greens and ...aw Sienna in the main and added a ...mall amount of Payne's Gray for the ...arker tones. Finally, a little white ...as been stippled with a hog-hair ...rush to soften areas where the ...now has drifted into the stubble.

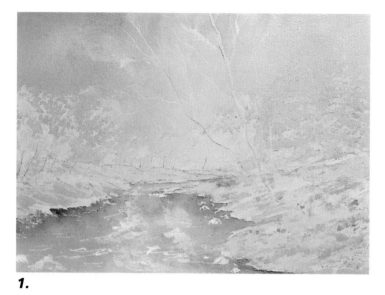

1.

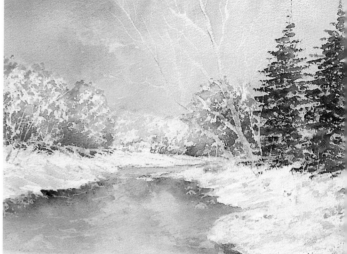

2.

In **Snow on the River** I'm going to show you a variety of watercolour techniques and how they can be combined to produce a successful painting.

1. MASKING AND POURING

After preparing the initial tonal study to establish the lights and darks and completing a simple drawing, I masked the tree shapes, the highlights I wanted to retain in the water and areas representing snow on the banks as well as areas of foliage.

Two washes were mixed in ceramic saucers, one using Cadmium Yellow Pale and one a mixture of Payne's Gray and Alizarin Crimson. The Cadmium Yellow mix was poured down the right-hand side of the painting and the Payne's Gray/Alizarin Crimson wash poured down the left-hand side. The board with the watercolour paper attached was inclined at a slight angle to allow the washes to flow down, blend together and run off the bottom of the paper.

2. PAINTING TREES

When the paint used in the first stage was dry, I painted the distant trees in light tones of Payne's Gray/Alizarin Crimson. Mixes of Raw Sienna and Burnt Sienna were applied to represent the bushes in the middle distance. I used the side of a size 14 round brush to paint the bushes. The fir trees were painted using a flat brush loaded with mixes of Permanent Sap Green and Payne's Gray.

3. REMOVING MASKING

Once the painting was completely dry, I removed the masking fluid by means of gentle rubbing with a putty eraser.

4. ADDING DETAILS

The tree shapes were painted with rigger brush by applying a Ra Sienna wash over the trunk followed by deposits of Burr Umber to make them look natura Using the sky colours, I painte shadows over the snow. The roc were painted with a flat brush: Ra Sienna for their under-painting ar Payne's Gray/Alizarin Crimson f the shadows under the rocks and the water. To complete this stag washes of Cadmium Yellow Pal Raw Sienna and a weak Alizar Crimson/Raw Sienna mix wei painted over the white of the pape which had been restored after th removal of the masking from th trees and bushes.

The colours used

Payne's Gray Alizarin Crimson Raw Sienna Burnt Umber Cadmium Yellow Pale Permanent Sap Green Burnt Sienna

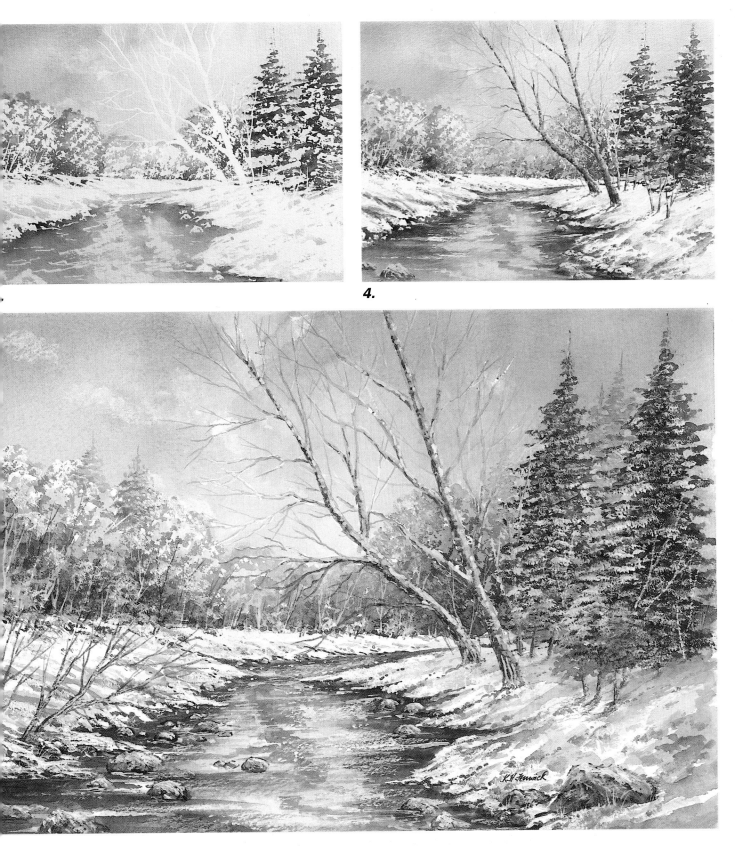

4.

BALANCING TONE AND COLOUR

complete this painting, I added a few more rocks in e river, painted darker tones of Payne's Gray/Alizarin rimson underneath the trees and bushes and painted e foliage on the two young trees on the right-hand side. I also added several fir trees in the distance and a large boulder in the right foreground. Small amounts of white acrylic paint were applied to the trees to represent snow.

We've already seen how useful it can be to include a feature in your painting other than what nature provides in the shape of the elements and the landscape. Many of the more common details are e. enough to paint. I'll show you how below.

SHEEP

When you come to paint sheep, think horseshoes. If the sheep is looking to the right, add a second horseshoe to extend the body to the right and then a triangle for the head. Naturally it is the same process only reversed if the animal is looking to the left – extending the body to the left and adding a triangle for its head. I use Payne's Gray/Burnt Umber to block in and then over-paint with either white acrylic paint or gouache. It's essential to add shadows beneath your sheep to make them look realistic.

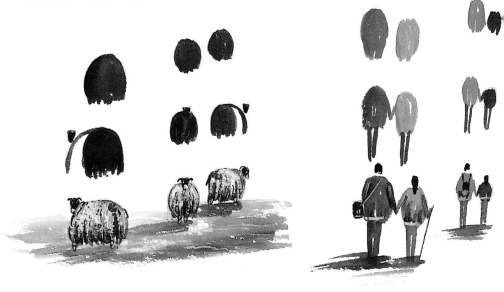

FIGURES

So you think you can't paint figures? If you follow the steps shown, you'll find easy. Before adding figures to your painting, it's a good idea to draw them fi on clear film or tracing paper using a felt tip pen and then place this over yo painting to determine the best position for them.

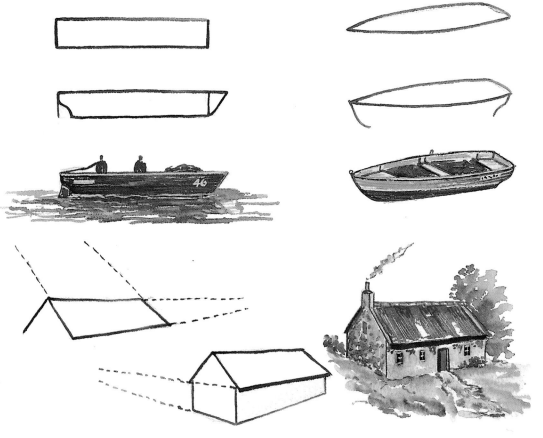

BOATS

Follow the simple stag shown and soon you will competent to add boats your paintings.

BUILDINGS

Here I have simplified th painting of a building. Th dotted lines are included help you simplify yo drawing and show yo how vanishing points g off into the distanc Linear perspective is th key to making yo buildings look realistic.

...become a successful artist it's essential to understand ...nal values, which I believe to be the most important ...ntributing factor to painting a successful landscape.

All paintings need contrasts of tone and the balance ...tween lights and darks arranged in relationships that ...hance the quality of the painting. Many beginners ...nd to splash paint on without any preliminary thought ...out the design of their painting, and as a result what ...ey produce looks flat and uninteresting.

It has always been my practice to clarify my thinking by producing small tonal sketches, using a dark brown water-soluble crayon. These sketches are only 3 x 4.5 inches in size and display little detail. Their purpose is to help me choose the best view of the landscape I am about to paint and to establish the best combination of light and darks. These tonal studies are simple scribbles but are vital to the success of my painting. If you produce tonal sketches to clarify your thinking before you apply paint, I guarantee that your paintings will improve significantly.

...ilizing Tonal Values

...e following are two distinct ways in ...hich tonal values can be successfully ...ilized in a painting, to ensure that ...ur work never looks flat:

...ounterchange is an effective way to ...ghlight the principal subject matter ... a painting, such as the focal point. ... emphasizing lights against darks ...d darks against lights, interesting ...atures can be made more distinctive. ...amples could be: surrounding the ...ght in a sky with darker contrasting ...nes of colour to make the light ...urce appear brighter; painting a light ...ned figure against the dark ...ackground of a building; or painting ...ark trees behind the light toned roof ...f a building.

...radation occurs when a colour ...radually changes, either from a light ...ne to a darker tone or the reverse. ...xamples could be the transition in ...olour from foreground grass to that in ...e distance or the transition in colour ...om wet to dry sand on a beach.

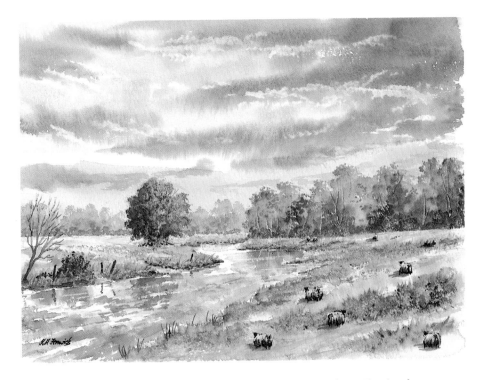

Autumn Fields was painted on a warm, early autumn day. The focal point was the lone tree on the left. Darker tones were painted into this to make it more distinctive. Note the variation in tonal values in the grass areas, necessary to create realism in the scene. The distant trees were painted in lighter tones to achieve recession. The variety of colours and tones in the right-hand tree grouping gives structure and depth to the painting. The dark posts and bush on the left-hand bank serve to balance the larger tree grouping on the right.

How to transfer an outline drawing of a completed painting onto watercolour paper

The next technique is not a substitute for learning to draw and should only be used until you are competent at drawing.

1. Take a black and white photocopy of the painting to the size required.

2. Using a soft pencil (6B), scribble across the back of the photocopy.

3. Position the photocopy over your watercolour paper, trace around the outline and key features using a biro or 2H pencil.

4. Remove the photocopy. The image will have transferred to your paper ready for you to apply paint.

Peace and Tranquillity depicts Scotland's salmon country. I was inspired by the atmospheric sky and the variety of tree species. The mountains provided the backcloth to the painting.

The only problem I encountered when painting this scene was presented by the many rocks in the river, which were time-consuming to paint.

I hope you enjoy painting this scene.

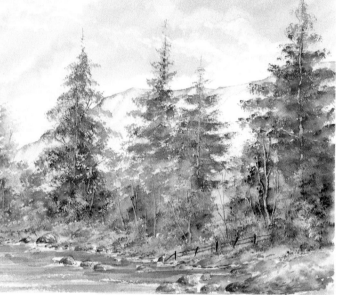

SKY AND MOUNTAINS

The sky is an important feature in this painting. The light from the sky softened the mountain structure and created sparkle on the surface of the water.

Skies such as this are easily painted. Apply the usual Raw Sienna wash, brush in the cloud shapes with, in this case, varying tones of blue and, to create the light effects, dab out some of the colour with a tissue to produce the feathery white clouds.

The mountains were painted with a hake brush, using sweeping directional strokes from peak to ground level. Shape your mountains by means of a tissue formed into a tight wedge, creating light areas by applying downward strokes at an approximate angle of 45° following the structure of the mountain. The colours used were Raw Sienna, Payne's Gray and Permanent Sap Green.

FIR TREES

Fir trees are quite easy to paint; simply use a flat brush and stipple, working upwards from ground level. As you stipple, rock the brush from side to side to define the shape, using more of the corner of the brush as you progress up each tree. Varying tones of Permanent Sap Green and Payne's Gray were used.

A number of bushes were painted in front of the fir trees to add variety of height, tone and colour. Some highlights were added to the foliage on the fir trees where the light reflected, using a mix of Cadmium Yellow and Permanent Sap Green with a little acrylic white added.

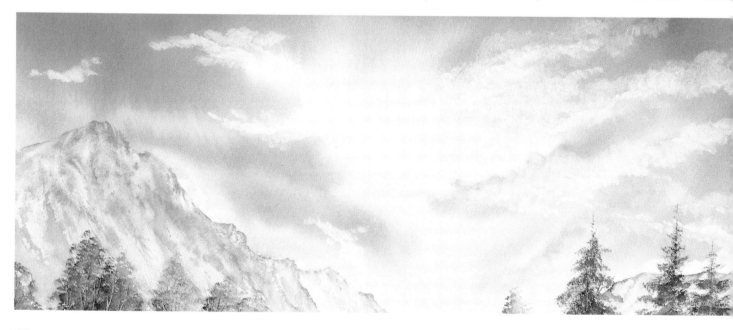

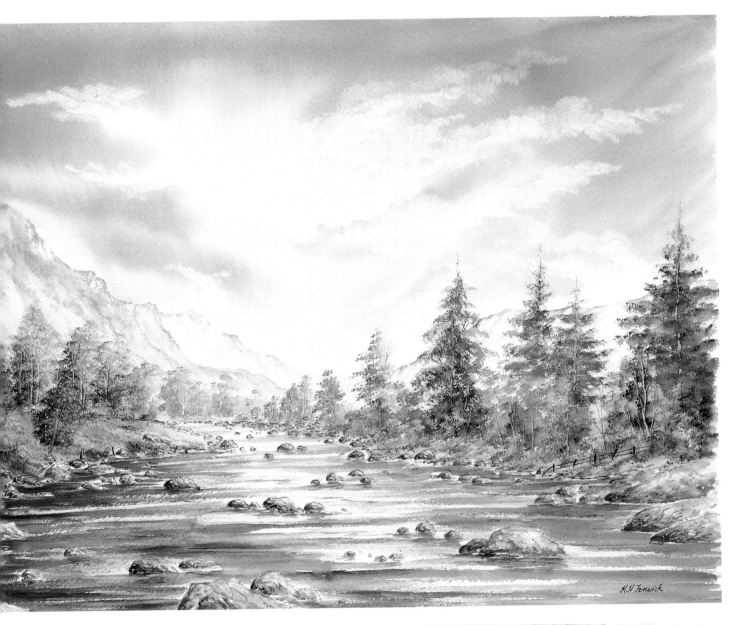

TREES, ROCKS AND RUNNING WATER

On the left bank were various young trees, their leaves changing colour as autumn approached. I stippled with a round hog-hair brush to create realistic looking foliage, using mixes made from Raw Sienna, Burnt Sienna, Permanent Sap Green and Payne's Gray.

When painting water it's a useful technique to partially close your eyes to allow observation of the various tones more clearly. A hake brush was used to paint the water, using Cerulean Blue/Payne's Gray mixes, taking care to leave lots of white paper uncovered to represent the light shimmering on the water.

A flat brush is ideal for shaping rocks. Paint a few of them at a time, applying a wash of Raw Sienna, followed by darker tones of Burnt Umber to give them shape. Don't forget to paint shadows under the rocks or they will look as if they are floating on the surface. This attention to detail distinguishes the more experienced painter from the beginner.

SPRING

It's spring, the new shoots are appearing, there's a fresh glow in the distance and the bluebells are in bloom. The birds are singing and everything in nature seems clean and new. Spring heralds the beginning of the artist's year.

When painting woodland scenes it's important to paint a simple sky that doesn't detract from the foreground detail. You must also design your painting so that the viewer's eye is taken beyond the foreground and into the distance. In this example I have used the path to lead the eye into the painting and out around the bend in the distance.

It's important to be able to paint a wide variety of greens. With four colours it's possible to mix over one hundred shades of green. For example, mix Payne's Gray and Raw Sienna together with varying quantities of water and you will create a range of very dark green, olive greens and yellow greens. By mixing Cadmium Yellow Pale with Payne's Gray you will get a wide range of grass- and yellow-greens in dark and medium tones. Using Payne's Gray (the darkest blue) produces colours that are basically dark in tone, which makes them ideal for capturing shadows and depth.

In this painting a range of bright, sparkling greens was produced by experimenting with mixes of Cerulean Blue and French Ultramarine with Cadmium Yellow Pale. Cerulean Blue mixed with Raw Sienna will give yellow greens.

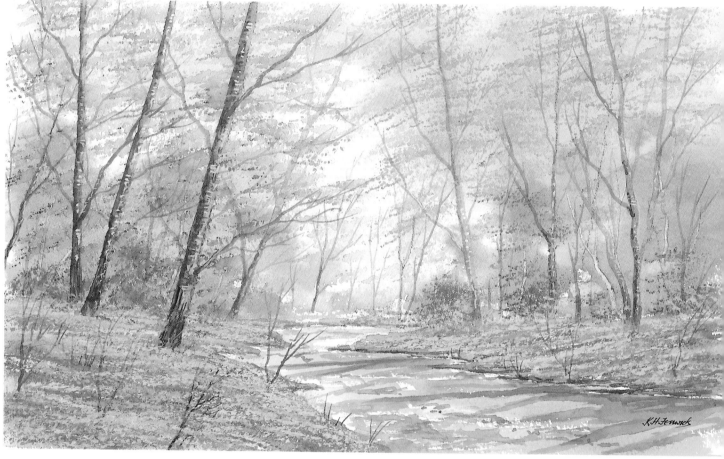

There are two techniques for painting bluebells. You can apply masking fluid, over-paint with greens, remove the masking and then paint over the white of the paper with French Ultramarine. Alternatively, you can paint the banks and when these are dry, over-paint with some white acrylic paint or gouache mixed with French Ultramarine. I chose the latter technique for this detail.

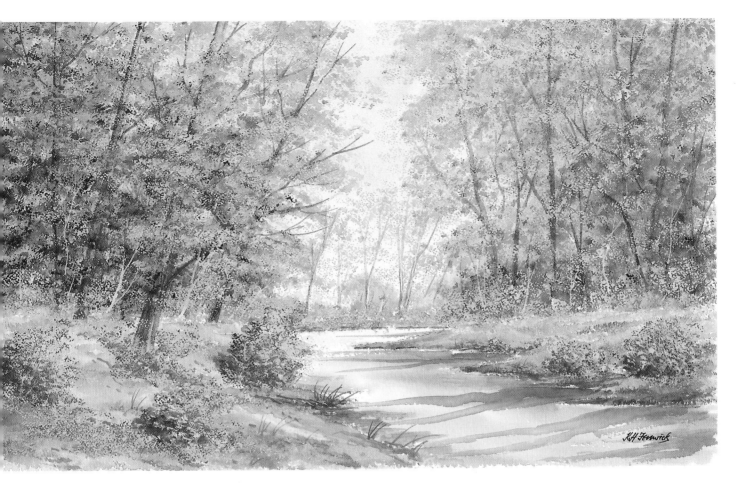

JMMER

s summertime and the tree structures can barely be seen
ue to the abundance of foliage. At ground level the grasses
e in full growth and surrounding bushes are waiting for
e young birds to leave their nests. The range of greens
d siennas used to depict this woodland scene creates
lashes of colour. The trees in full leaf cast shadows across
e path, leading the eye into the distance.

Trees appear dark on the inside with light foliage
arkling on the outside. The water colourist paints light to
rk, which conflicts with the previous statement and what
observed in nature.

My method when painting trees is to follow convention
it after I have added darker tones to create depth, I will

finish with touches of bright colour to soften the effect and
create highlights.

Don't use black for shadows. Mix 20 per cent of any
colour on your palette with 80 per cent Payne's Gray and
you will produce an extensive range of blue, brown, red or
green shadow colours that can be used where appropriate.
My personal favourite for tree shadows is a mix of Payne's
Gray with a small amount of Alizarin Crimson added.

To paint the grasses, I used a soft yellow green wash and
stippled with darker tones of green using a hake and a hog-
hair brush. I used a small natural sponge dipped in paint to
stipple on the foliage. For the final highlights, I stippled with
a round hog-hair brush once the under-painting had dried.

this vignette, I used combinations of
admium Yellow Pale, Cerulean Blue, Raw
enna, Burnt Umber and Payne's Gray.

ATMOSPHERE, MOOD AND LIGHT *The seasons*

AUTUMN

It is now autumn, my favourite time of year. The leaves have changed colour, and are now displaying a wonderful array of soft yellows to deep red-browns. Nature's colours are at their best at this time of year, and offer the landscape painter an abundance of majestic scenes to paint as well as opportunities to experiment with colour mixing.

As the trees change from their summer to autumn colours the woodland displays a great variety of s greens, yellows, siennas, ochres and rich red-brown Only touches of green are evident.

The less experienced painter will find t representation of foliage most difficult, whether th want to paint loosely or in great detail. In this painti the foliage was painted with a sponge, using stippling technique.

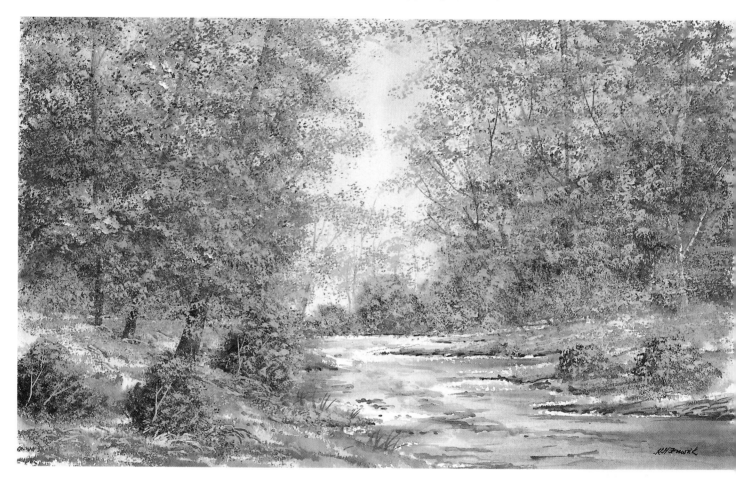

The benefits of painting the same scene

Painting the same scene at different times of the year can be a fascinating and illuminating experience. It's both exciting and beneficial to your development as a landscape painter because it teaches you so much about colour mixing and gives you practice in a range of different techniques.

To paint this vignette, I mixed various colours from the selection Cadmium Yellow Pale, Raw Sienna, Alizarin Crimson, Burnt Sienn Burnt Umber and Payne's Gray.

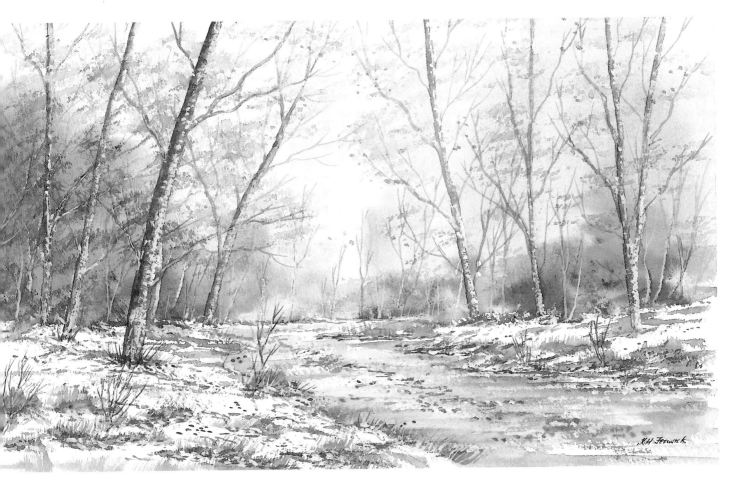

WINTER

Winter has arrived. The leaves have fallen, except for a few determined to keep their lofty positions. The distant woodland appears diffused, yet the glory of what had been can still be seen in the occasional splash of colour. The ground is lightly covered in snow, with the young saplings and stubble projecting upwards.

Such a scene demands a simple background sky. In this example, a few downward strokes of a hake brush loaded with Cerulean Blue over a Raw Sienna under-painting sufficed. The painting will look too fussy if a complex sky is painted. Remember the 'Golden Rule': a detailed foreground demands a simple sky – a simple foreground requires an atmospheric sky.

The background trees were painted wet into wet, to create a diffused effect. This was achieved by using the corner of a hake brush, when the sky was approximately one-third dry. I scratched in the tree structures using a palette knife; a cocktail stick would also have done the job.

Timing is vital here. If the tree structures are to look almost white, the under-painting must not be too wet otherwise the paint will run back and you'll get dark tones. Experience will tell you when the time is right to begin scratching out.

This vignette shows the technique I used for painting the tree trunks. I defined the structure of the trees first by drawing them with a flat brush loaded with raw sienna. When the paint was approximately one-third dry, I removed some colour from the length of the trunk with a tissue shaped to a point. Finally, I used a rigger brush to paint some detail on the trunk using darker tones of Payne's Gray/Burnt Umber.

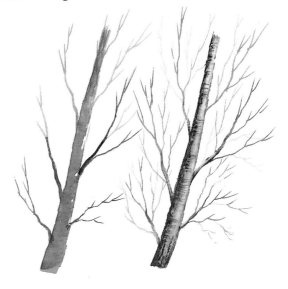

43

ATMOSPHERE, MOOD AND LIGHT *Techniques close up*

When writing these books, it was never my intention to attempt to impose a style of painting on anyone, but rather to show different techniques which would allow you to stamp your own style on your paintings with both confidence and pleasure. I like to think of an artist's style as being akin to handwriting in paint. You may wish to paint in a loose, free style or perhaps represent the landscape in detail. Over time you will develop your own style of painting – it can't be imposed on you.

Woodland Beck incorporates all the techniques described in this book. I used acrylic watercolours, but I could have used traditional watercolour paints just as easily.

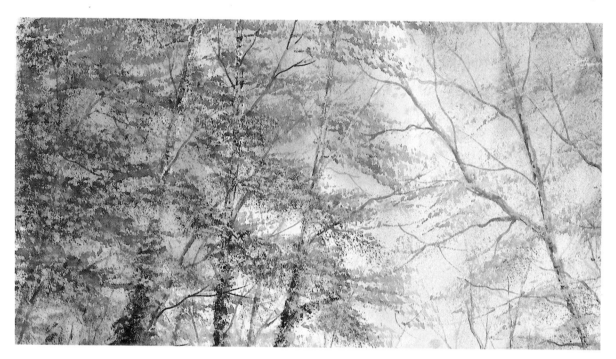

FOLIAGE

After the tree structures were drawn in, the foliage was painted by initially stippling dark tones of a Payne's Gray/Permanent Sap Green mix. When this dark under-painting was dry, lighter greens were stippled over it. I used a round hog-hair brush (oil painter's brush) for this technique. The beauty of acrylics is that you can easily work light to dark or dark to light.

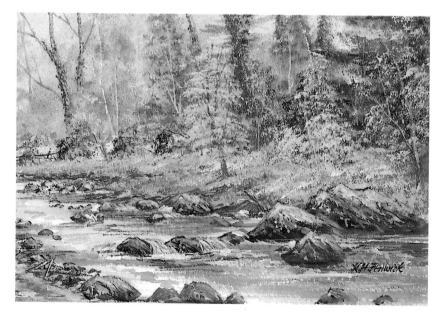

WATER

Initially I painted the fast-flowing wate between the rocks. This was done by dippin the hairs of a round brush in Payne's Gra and then fanning them between thumb an finger to create irregular sections. The fin hairs were then quickly brushed between th rocks, which had the effect of leaving whit paper uncovered to represent the runnin water.

I used a round, pointed brush with mixe of Payne's Gray and Cerulean Blue to add variety of tones to complete the beck. Th strokes were horizontal in direction. A littl Raw Sienna was brushed in to represen reflections from the background light.

44

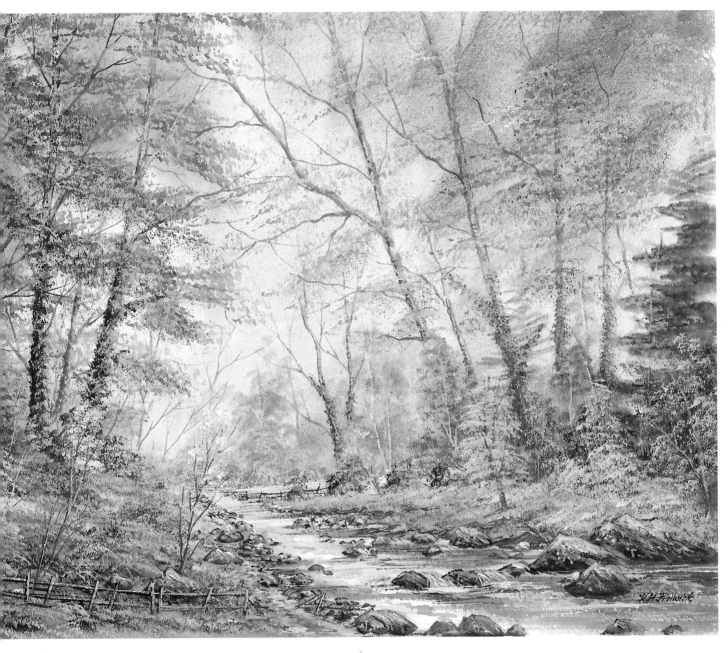

TEXTURE

There's considerable detailed texture in this painting to reflect the plant life you find when walking through woodland – tufts of grass, young bushes and saplings and, in this case, a carpet of bluebells.

Over the years, I have experimented with various brushes to achieve a natural look for depictions of a woodland floor. I find that stippling with an old oil painter's brush gives my preferred result, and I've used this method here.

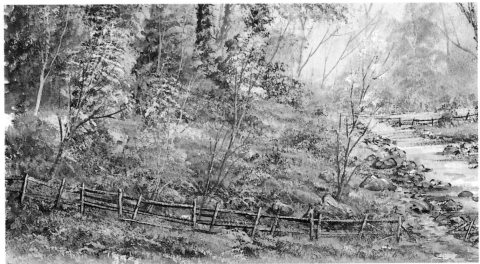

ATMOSPHERE, MOOD AND LIGHT *Project*

Every artist dedicated to their work will be continually experimenting with new techniques to create paintings that stir their emotions. You might be fired to capture a sense of realism, the beauty of nature's creation or simply to complete a painting with which you are happy.

Experimentation is important if you want to be able to call on a wide range of techniques in your paintings. I have been able to produce sever interesting landscapes by using different technique such as controlling the flow of paint with maskir fluid or masking tape, pouring paint from sauce scumbling, glazing, knifing out or spattering.

Autumn Flow is one such painting. I'm delighte to have the opportunity to show you some of th techniques I used to paint it.

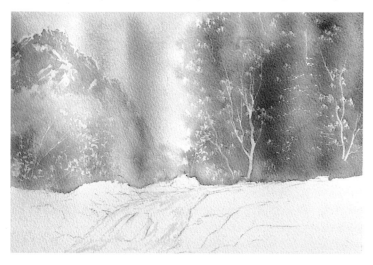

1. MASKING AND POURING

An initial tonal study was completed and the outline of t painting drawn. Masking was applied by brush to t mountains and the water and to the foliage with a crumpl piece of grease-proof paper. A cocktail stick dipped in maskir fluid was used to draw the tree structures.

The sky was painted with a hake brush loaded with mix of Cerulean Blue and Alizarin Crimson and then allowed to d.

The mountain was painted using a weak mixture of Payne Gray and Alizarin Crimson and allowed to dry.

Washes of Raw Sienna, Burnt Sienna and Payne's Gr were pre-mixed in ceramic saucers and poured over the tr areas after the tops of the rocks had been masked out with piece of masking tape to prevent the washes from runnir below this line. The board was tilted to allow the washes run slowly and merge together. The paper was then laid flat dry, with a hair dryer eventually used to ensure the paint w completely dry.

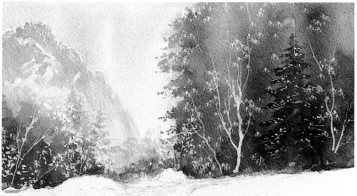

2. ESTABLISHING TONAL VALUES

Further pourings of the paint added depth to the trees. Whe this was dry the rough shapes of the fir trees were painte with a flat brush loaded with a Permanent Sap Green/Payne Gray mix. The distant fir trees on the left were painted usinç weaker mix.

3. REMOVING THE MASKING

The distant mountains were given more definition by applyir a Payne's Gray/Alizarin Crimson wash. When this was dry putty eraser was used to remove the masking from th mountains and the areas of foliage.

Painting the rocks is a very easy process, and comes nex Washes of Raw Sienna followed by Burnt Sienna and Payne Gray are applied to selected areas. A palette knife is then use to shape the rocks. The paint isn't applied with the knife bi simply moved around to create the shape of the rocks. At th end of each stroke of the knife, the build up of paint leaves dark edge, representing shadows. The paper isn't damaged any way by this.

Finally the masking was removed from the waterfall an the waterfall painted in a Payne's Gray/Cerulean Blue m using light strokes with a hake brush following the directio of flow. The rocks projecting through the water were painte using a flat brush loaded with the colours used previously.

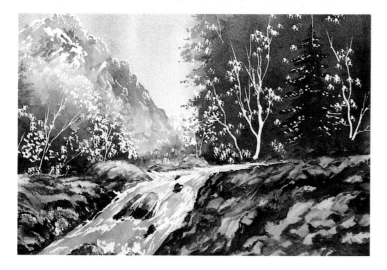

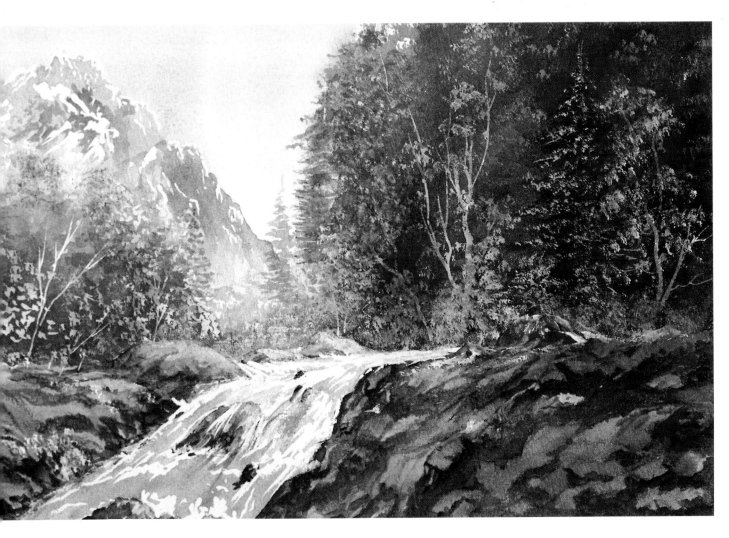

ADDING DETAIL

s time to bring the painting together and add the ishing touches. Raw Sienna, Cadmium Yellow Pale d Burnt Sienna glazes were applied to the foliage d tree structures. These same glazes were also ed to colour the rocks and create depth of tone.

Highlights to the foliage were then applied. Paper asks had to be first cut to shape to protect other eas, such as the sky; I used a piece of mounting rd cut to various profiles to fit around the trees. To ply the paint, I took an old toothbrush, dipped it Cadmium Yellow Pale, ran my thumb over the istles and then spattered the colour onto the liage.

Taking time to get it right

I rarely complete a painting in one sitting. I prefer to work on it over several days, looking at it critically and making any changes I feel are necessary. I might remove paint to lighten areas or apply glazes (a little paint mixed with lots of water) to improve the variation of colour and tone.

Using the above process, I have been able to produce several interesting landscapes and enjoy this different approach to painting. I recommend you try these methods – above all, have fun and enjoy your painting.

The colours used

| Payne's Gray | Alizarin Crimson | Raw Sienna | Cerulean Blue | Cadmium Yellow Pale | Permanent Sap Green | Burnt Sienna |

PORTRAIT OF THE ARTIST

Keith Fenwick is one of the UK's leading teachers of painting techniques. He enjoys a tremendous following among leisure painters, who flock to his demonstrations and workshops at major fine art and craft shows.

Keith is a Chartered Engineer, a Fellow of the Royal Society of Arts, an Advisory Panel member of the Society for All Artists and holds several professional qualifications including an honours degree. He served an engineering apprenticeship, becoming chief draughtsman, before progressing to senior management in both industry and further education. He took early retirement from his position as Associate Principal/Director of Sites and Publicity at one of the UK's largest colleges of further education in order to devote more time to his great love, landscape painting.

Keith's paintings are in collections in the United Kingdom and other European countries, as well as in the United States, Canada, New Zealand, Australia, Japan and the Middle East.

Keith runs painting holidays in the UK and Europe, seminars and workshops nationwide and demonstrates to up to 50 art societies each year. Keith can be seen demonstrating painting techniques at most major fine art and craft shows in the UK. He has had a long and fruitful association with Winsor & Newton, for whom he is a principal demonstrator.

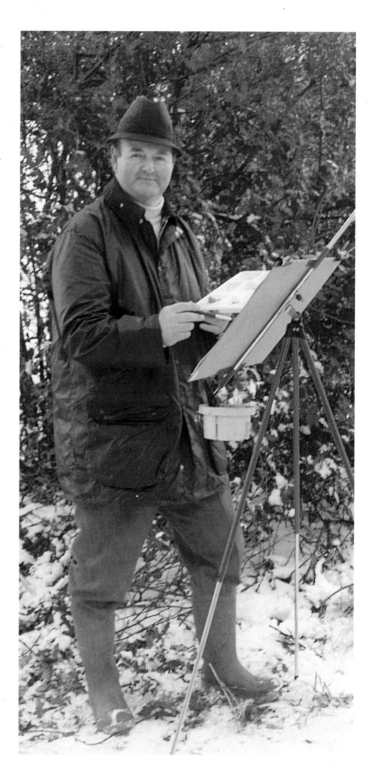

Keith's expertise in landscape painting, his writings, teaching, video-making and broadcasting ensure an understanding of student needs. His book *Seasonal Landscapes* has proved very popular, as have his 20 best-selling art teaching videos, which have benefited students worldwide. He is a regular contributor to art and craft magazines.

Keith finds great satisfaction in encouraging those who have always wanted to paint but lack the confidence to have a go, as well as helping more experienced painters to develop their skills further. He hopes this series will be a constant companion to those wishing to improve their skills and experiment with new ways to paint the landscape.